IMAGES
of America

ROSIE THE RIVETER IN LONG BEACH

IMAGES
of America

ROSIE THE RIVETER IN LONG BEACH

Gerrie Schipske

ARCADIA
PUBLISHING

Published by Arcadia Publishing
Charleston SC, Chicago IL, Portsmouth NH, San Francisco CA

Printed in the United States of America

Library of Congress Catalog Card Number: 2007940253

For all general information contact Arcadia Publishing at:
Telephone 843-853-2070
Fax 843-853-0044
E-mail sales@arcadiapublishing.com
For customer service and orders:
Toll-Free 1-888-313-2665

Visit us on the Internet at www.arcadiapublishing.com

*To the Women's Studies Department of
California State University Long Beach
for continuously encouraging women that "We Can Do It!"*

CONTENTS

ACKNOWLEDGMENTS

Special thanks go to the people who graciously provided access to photographs and memorabilia for this book. These people include: Patricia McGinnis, archivist and historian, Boeing Historical Archives; and James L. Turner, retiree and volunteer extraordinaire, The Boeing Company. Thank you also to the members of the Rosie the Riveter Long Beach Task Force, who are working diligently to create a lasting memorial to the women who worked in Long Beach, California.

ROSIE THE RIVETER PARK IN LONG BEACH

In 2000, the U.S. Congress established the Rosie the Riveter World War II Home Front National Historical Park in Richmond, California, as part of the national park system. This park contains a memorial to the women who worked in the Richmond-area Kaiser shipyards.

Four years later, Congress passed House Concurrent Resolution 413 honoring the contributions of women, symbolized by "Rosie the Riveter."

In 2007, I requested the Long Beach City Council to rename a one-acre park adjacent to the site of the former Douglas Aircraft Plant the "Rosie the Riveter Park." As I researched the contributions of these women and the changes they made forever to the role of women and to the City of Long Beach, I knew that I needed to write this book.

The images in this book provide a glimpse of the "Rosies" who worked in the Douglas Aircraft Plant in Long Beach. They are just a fraction of the photographs and documents chronicling the contributions of these women in the archives of the Library of Congress, the Franklin Delano Roosevelt Digital Archives, the NARA and Records Administration (NARA), the Northwestern University Library Collection, the Long Beach Airport, and the Boeing Corporation.

I hope you will enjoy getting to know the many "Rosie the Riveters" who worked in Long Beach.

—Gerrie Schipske

INTRODUCTION

This is the story of the women who worked in the Long Beach, California, aircraft plant that produced the mighty bombers, fierce attack planes, and gigantic troop/cargo tankers that helped the United States win World War II. It is also part of the story of how these women came to Long Beach and became known as "Rosie the Riveter."

It begins with the development of the Long Beach Municipal Airport. Strategically located on the West Coast adjacent to railroads and ports, the airport became one of the most successful municipal airports in the United States in the late 1930s. The U.S. Army Air Corps and the U.S. Navy located some of their operations at the Long Beach airfield prior to World War II.

Following the rise to power of Adolph Hitler and the invasion of Poland by Germany, Pres. Franklin Delano Roosevelt, in his December 29, 1940, "fireside chat," called for "the rearmament of the United States" by demanding that "guns, planes, ships and many other things have to be built in the factories and the arsenals of America. They have to be produced by workers and managers and engineers with the aid of machines which in turn have to be built by hundreds of thousands of workers throughout the land."

Days before his radio address, President Roosevelt established the Office of Production Management to oversee the "gigantic production" of wartime munitions and supplies. "We must be the great arsenal of democracy," Roosevelt declared.

Aircraft manufacturer Donald W. Douglas responded to Roosevelt's call. Douglas, whose aircraft plants were located in Santa Monica and El Segundo, California, and Tulsa, Oklahoma, had successfully built the DB-7, a plane converted into the A-20 Havoc or the Boston, a popular attack plane used by the French and British before the United States entered the war.

The U.S. Army Air Corps saw great value in the DB-7 as a medium attack bomber and decided to build an aircraft plant in Southern California to mass produce it, along with longer-range bombers (B-17) and cargo planes (C-47).

The army selected a 242-acre tract located 22 miles south of Los Angeles adjacent to its Long Beach Army Air Base on the Long Beach Municipal Airport. The Douglas Aircraft Company was chosen to manage the plant.

When the ground was broken for the Douglas Aircraft Plant, Long Beach was a sleepy coastal resort town at the end of the Pacific Electric Red Car line, which connected it with Los Angeles. Long Beach was growing due to oil and its port facilities. Having rebuilt its downtown area following the magnitude-6.3 earthquake in 1933, Long Beach soon became a focal point of military activity. The U.S. Navy began construction of a 393-acre harbor-front base within months of the Douglas Aircraft Plant opening on October 17, 1941.

The Long Beach Douglas Aircraft Plant facility cost $12 million to build and was a massive 1,422,350 square feet of covered workspace comprised of several buildings constructed of concrete and steel. The Long Beach plant was larger than the combined Douglas plants at Santa Monica and El Segundo.

The roofs of the buildings were elaborately camouflaged with fake canvas houses, wire trees, and painted streets that gave the appearance of a suburban neighborhood in order to make certain that the plant did not become the target of enemy bombers. Thick netting covered spaces between the buildings. Sandbags were piled high near the many bomb shelters built for employees.

Windowless yet air-conditioned, the buildings used thousands of glare-less, fluorescent, and mercury vapor lights to create "daytime" 24 hours a day, seven days a week.

To meet the production quotas set by the U.S. Army, Douglas Aircraft (as well as the other wartime manufacturers) needed to employ tens of thousands of workers. With the creation of the

nation's first peacetime draft in 1940 and the declaration of war in 1941, all eligible males were conscripted into military service, seriously depleting the traditional labor pool.

The U.S. Office of War Information (OWI) launched an intensive propaganda effort to convince women to take jobs in aircraft plants, shipyards, munitions factories, and anywhere else to supply the military with material to win the war.

The image of women working in the defense industry, clad in overalls and hardhats, was popularized in song in 1943 by the Redd Evans and John Jacob Loeb tune "Rosie the Riveter," recorded by the Vagabonds. Shortly after the song was released, the Memorial Day issue of the *Saturday Evening Post* magazine featured a cover illustrated by Norman Rockwell showing a muscular, red-headed woman wearing overalls, loafers, and a welder's mask, surrounded by the American flag and the name "Rosie" written across her lunch pail. Thereafter, women working in the war industry were referred to as "Rosie the Riveter."

The 1944 OWI "Women in the War" campaign included posters, flyers, news reels, radio broadcasts, music, magazine articles, and movies that sent the message to women of all ages and races that it was their patriotic duty to leave their homes and take jobs normally held by men.

Douglas's Long Beach plant launched its own successful recruitment campaign by sending "Victory Scouts" (Boy Scouts) door-to-door to recruit women workers and through advertisements in newspapers and the *Teachers Journal*, the publication of the Long Beach City Teachers Club.

A Long Beach Douglas female worker was depicted in a popular poster circulated across the nation to encourage women to take defense industry jobs. The campaign led to an increase in the number of women employed in the war effort from 500 in January 1942 to more than 30,000 by the year's end. Throughout the United States, an unprecedented number of women were working in non-traditional jobs.

Over the course of the war, the Long Beach plant employed over 175,000 employees, 40 percent of whom were women. The "Rosies" who worked at the Long Beach plant riveted, but they also welded, assembled parts, and performed every type of job needed to produce bombers and cargo planes.

The Douglas Aircraft Plant in Long Beach was considered to be so critical to the success of the war that Pres. Franklin Roosevelt personally visited it in 1942. During the war, the Douglas Aircraft Company produced approximately 16 percent of the U.S. aircraft used in the war, turning out an airplane an hour at the height of production.

Once the war was over, Douglas Aircraft (like all other defense plants) sent the women home in order to make way for the men who came back from military service. A propaganda campaign, again aimed at women, stressed how important it was for women to return to their homes (and feminine attire) so the men could reclaim the jobs and the role they had left behind.

Douglas Aircraft continued manufacturing commercial and military airplanes until 1967 when it merged with the McDonnell Company. In 1997, Boeing and McDonnell Douglas merged. The Long Beach plant still produces the C-17 cargo plane for the U.S. Air Force.

One

CREATING AN ARSENAL OF DEMOCRACY IN LONG BEACH

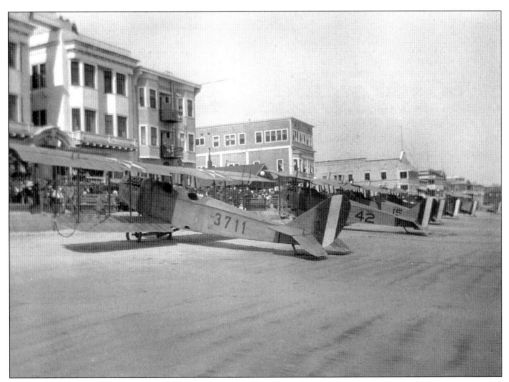

AVIATION IN LONG BEACH. Prior to the construction of a 150-acre municipal airport in 1923, pilots could be seen taking off and landing on the long strand of beach for which Long Beach, California, is named. As commercial aviation grew, so did the Long Beach Municipal Airport and the military's interest in locating its operations in this Southern California city. (Long Beach Airport Archives.)

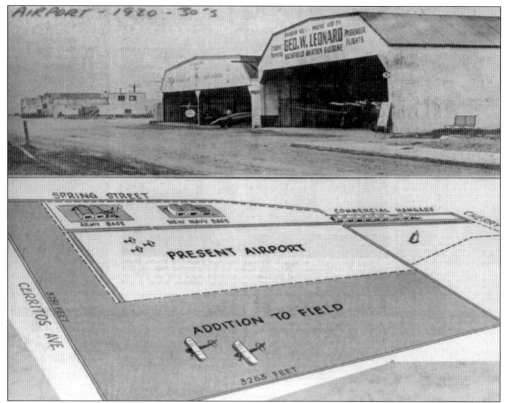

DAUGHERTY FIELD. The Long Beach Municipal Airport was situated near the intersection of Spring Street and Cherry Avenue and was named Daugherty Field in honor of Earl S. Daugherty, a pioneer aviator. The city used the airfield to attract the U.S. Navy by offering to lease it for $1 a year if the navy built a naval reserve air base. The city also constructed a hangar and other facilities on the airfield for the U.S. Army Air Corps. (Above, Long Beach Airport Archives; below, Long Beach Heritage Museum.)

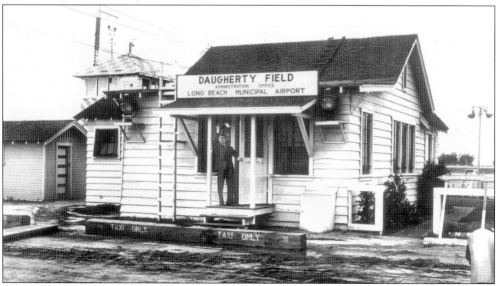

EXPANSION OF COMMERCIAL AVIATION. Relations between the City of Long Beach and the U.S. Navy soon soured because the city wanted the municipal airfield to become the site of expanding private and commercial aviation, as shown in the picture. United, TWA, American, and Western Airlines all provided service from the Long Beach Airport in the late 1930s. After the Long Beach city manager proclaimed that the city wanted the navy to leave, the navy purchased property offered by Susanna Bixby Bryant and relocated its air station to Los Alamitos. Instead of returning the airfield to the City of Long Beach, the navy transferred the property to the U.S. Army Air Corps, which operated a base near the airfield. A small naval auxiliary air station remained at the Long Beach airfield. (Long Beach History Collection, Long Beach Public Library.)

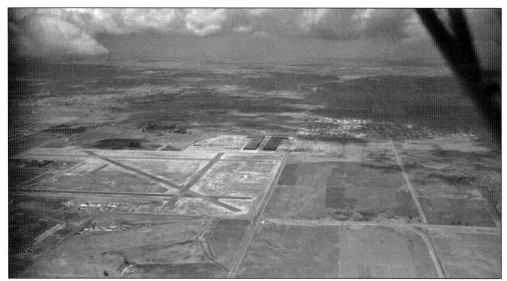

LOOKING NORTH AT LONG BEACH AIRPORT. By the late 1930s, the Long Beach Municipal Airport was one of the largest and busiest municipal airports in the United States. Equipped with five long runways that were lit at night, the airfield accommodated the army, the navy, and commercial air traffic. Aviator Charles Lindberg, who used the Long Beach Airport for an emergency landing, praised the airport for its advanced features. During the war, the field became known as the Long Beach Army Airfield and was home to the 18-person squadron of women air service pilots (WASP) of the 6th Ferrying Group of the Army Air Transport Command, who flew thousands of military aircraft in and out of the Long Beach location. (Long Beach Airport Archives.)

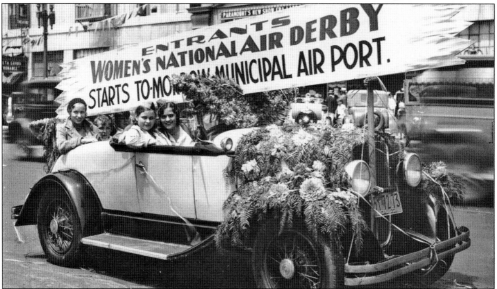

FLYING HOUSEWIFE. From the early 1920s, Long Beach led the nation in the number of women involved in aviation as pilots, flying instructors, or in manufacturing airplanes. Ameila Earhart took flying lessons in Long Beach. Gladys O'Donnell was one of the most famous of Long Beach's women aviators. O'Donnell flew the *Miss Long Beach* and beat Earhart in the 1929 National Women's Air Derby, earning the nickname "The Flying Housewife." She and her husband, Lloyd, were involved in Long Beach aviation for many years. (Long Beach Airport Archives.)

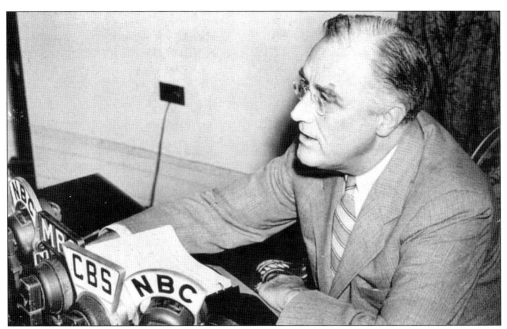

FIRESIDE CHAT. On December 29, 1940, Pres. Franklin Delano Roosevelt delivered a radio address calling for Americans to support efforts to bolster European countries' fight against Hitler and his Nazi army. Roosevelt stressed that the United States could "stay out" of the war if it helped produce planes, guns, tanks, and ships needed by Great Britain and France. "I want to make it clear that it is the purpose of the nation to build now with all possible speed every machine and arsenal and factory that we need to manufacture our defense material," said Roosevelt, paving the way for the Douglas Aircraft Plant in Long Beach, California. (Library of Congress.)

ARSENAL OF DEMOCRACY. Pres. Franklin Roosevelt sent his appeal to industry leaders such as Donald Douglas to increase the production of military ships, planes, munitions, and other items needed by U.S. allies in Europe. Roosevelt urged Congress to appropriate millions of dollars to "to help provide for the enlargement of factories, the establishment of new plants, the employment of thousands of necessary workers, the development of new sources of supply for the hundreds of raw materials required, the development of quick mass transportation of supplies." (NARA.)

RADIO ADDRESS OF THE PRESIDENT
DELIVERED FROM THE WHITE HOUSE
December 29, 1940, 9.30 P.M.

MY FRIENDS:

This is not a fireside chat on war. It is a talk on national security; because the nub of the whole purpose of your President is to keep you now, and your children later, and your grandchildren much later, out of a last-ditch war for the preservation of American independence and all of the things that American independence means to you and to me and to ours.

Tonight, in the presence of a world crisis, my mind goes back eight years (ago) to a night in the midst of a domestic crisis. It was a time when the wheels of American industry were grinding to a full stop, when the whole banking system of our country had ceased to function.

I well remember that while I sat in my study in the White House, preparing to talk with the people of the United States, I had before my eyes the picture of all those Americans with whom I was talking. I saw the workmen in the mills, the mines, the factories; the girl behind the counter; the small shopkeeper; the farmer doing his spring plowing; the widows and the old men wondering about their life's savings.

I tried to convey to the great mass of American people what the banking crisis meant to them in their daily lives.

Tonight, I want to do the same thing, with the same people, in this new crisis which faces America.

We met the issue of 1933 with courage and realism.

We face this new crisis -- this new threat to the security of our nation -- with the same courage and realism.

13

France *France*

October 30, 1939.

French purchases in the United States.

Since October 23, the French Missions have placed to date the following orders, subject to a contingent clause in case the arms embargo should not be lifted.

1.- WHITE MOTOR CO., Cleveland Ohio. Contract of
October 19,1939. 1500 trucks at $2,008.98 F.O.B.
 Cleveland..........$ 3,013,470.
 spare parts....................... 100,000.
 TOTAL amount of contract...........................$ 3,113,470.

2.- E.W. BLISS CO, Brooklyn, N.Y. Contract of
October 24, 1939. 3 machine tools (presses)........$ 112,000.

3.- CHRYSLER CORPN., Detroit, Michigan. Contract of
October 26, 1939. 1500 trucks type VH48 at $1,134.75:$ 1,702,125.

4.- DOUGLAS. 100 motors DB7. Contract of October 20,1939:$10,483,200.

5.- CURTISS WRIGHT. propellers.
 Contract of October 31,1939:$ 9,158,125.

a23e01

SECRET DOCUMENTS ON DOUGLAS PLANE ORDERS. Despite the officially stated policy of U.S. neutrality, both of these documents found in Pres. Franklin Delano Roosevelt's White House safe after his death reveal that the U.S. government was encouraging the production of military aircraft by various U.S. manufacturers. The documents here detail a portion of the French and British orders for warplanes from several U.S. aircraft manufacturers, including the Douglas Aircraft Plant in Santa Monica, California. Both the French and the British appreciated the power and versatility of the Douglas DB-7 ("D" for Douglas and "B" for bomber), which had been designed in 1937. (Franklin Delano Roosevelt Digital Archives.)

PSF Safe : France

October 16, 1939.

French purchases in the United States.

Since October 9 , the French Air Commissions has placed to date the following orders, subject to a contingent clause in case the embargo on arms should not be lifted:

1). Contracts signed:

North American: 200 planes Model BT9, same as pre-war
 order, and 40 spare engines................$ 5,501,473.20

Douglas: 170 planes DB7 and spare parts.......... 15,838,305.00

United Aircraft: 600 engines and 600 propellers... 7,591,000.00
 (option lifted on a previous contract)

Indian Motorcycle Co.: 5000 motorcycles.......... 2,409,750.00

2). Contracts to be signed:

Douglas: 100 planes A.20, subject to decision
 of U.S. Army.......... Price not yet
 settled.

Wright: 455 motors double speed....... "

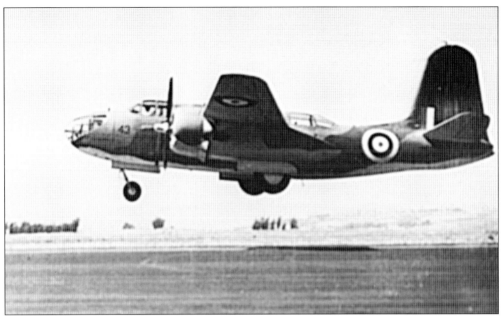

DOUGLAS MILITARY ARMY AIRCRAFT. Douglas Aircraft produced more than 7,000 A-20s before and during World War II. After modifications were made to the plane, the British version (shown above) was called the A-20 ("A" for attack) Boston and was used by the British Royal Air Force. The light bomber was designed as an attack bomber to strike ground troops and installations. The U.S. Army Air Corps renamed the plane Havoc and also used it as a night fighter. The photograph below shows the Douglas A-20 Havoc being flown over the coast of California. The success of the DB-7/A-20 was instrumental in the U.S. Army funding an aircraft plant on its airbase located in Long Beach, California. (Both, Copyright The Boeing Company.)

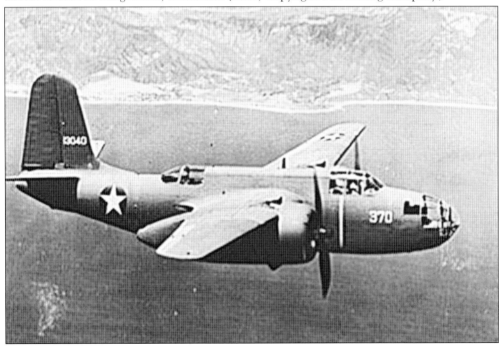

THE FUTURE SITE OF THE DOUGLAS AIRCRAFT PLANT. The photographs show the land that eventually would become the Douglas Aircraft Plant. Looking southwest from Carson Avenue in the photograph above, undeveloped fields can be seen with the faint outline of the oil-well-dotted Signal Hill in the background. Below, the photograph shows a view from Carson Avenue with dairy farms on the horizon on present-day Paramount Avenue. The Montana Land Company sign reminds that a great deal of the land is private property. Adjacent to an airfield, naval and army airbases, and a railroad, and just miles from a port, the property was ideally suited to be the site of an aircraft plant that would serve the growing military needs. (Both, Copyright The Boeing Company.)

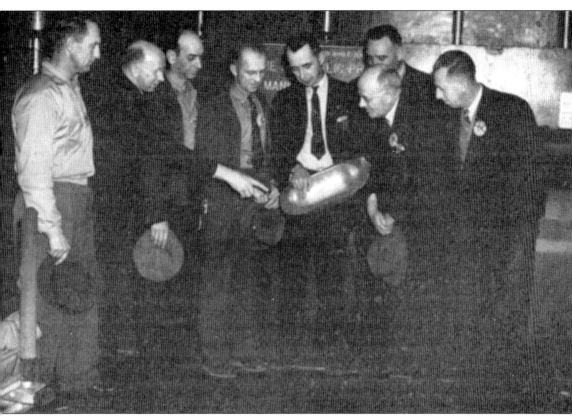

PARTNERSHIP WITH LONG BEACH CITY SCHOOLS. One of the reasons Long Beach was selected as the site for the new aircraft plant was the considerable number of available workers with experience in shipyards, oilfields, machine shops, foundries, and sheet-metal plants that could be retrained for the aircraft industry. Before construction of the Long Beach plant began, Douglas officials met with Long Beach City Schools' officials to set up an extensive program to train men and women in aviation manufacturing and materials. The program was run at the John Dewey Trade School on Olive Street and at the Long Beach City College. Classes were conducted day and night, turning out more than 1,000 students a month. The close relationship between Douglas Aircraft and the Long Beach City Schools continued throughout the war. (Copyright The Boeing Company.)

GROUNDBREAKING. Ten months after plans were announced for a new aircraft factory, Donald Wills Douglas sits on a bulldozer during the groundbreaking ceremony (left) and then turns over the first shovel of soil for the Long Beach aircraft plant on November 22, 1940, at the Long Beach Municipal Airport (below). The Long Beach Municipal Band provided music for the event. The initial plans called for a 142-acre site, but that was later expanded to 242 acres. The Long Beach plant was funded by the U.S. Army, and Douglas Aircraft was retained to manage the plant. Douglas, whose first plane, the Cloudster, was produced in 1920, began his aircraft business in the back of a Santa Monica barbershop. Douglas designed a number of planes used by the U.S. Army, including dive-bombers, attack bombers, and cargo and transport airplanes. (Both, Copyright The Boeing Company.)

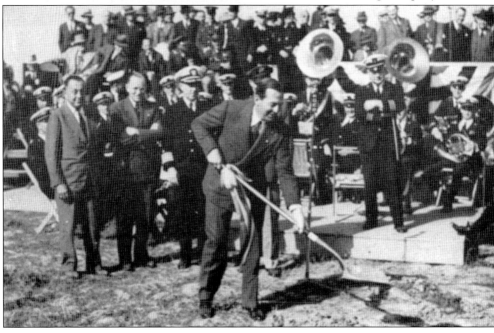

Over 242 acres spreads the vast new Long Beach plant of the Douglas Aircraft company, part of the Arsenal of Democracy.

FORTRESS like walls would shelter workers inside from bomb fragments.

FULL SPEED AHEAD

❋ THE Douglas Long Beach plant, with its formal dedication, was given further momentum in its airplane production program well under way as a great part in the nation's defense plan.

Production in this great "Arsenal of Democracy" which was designed and built under the national defense program is now into the great race against time for the establishment of national preparedness and the longevity of democracy.

Those fortress-like walls of steel and concrete house the workmen, the engineers, the planners and the administrators of America's newest and most modern aircraft defense project.

The plants' original cost is estimated at $12,000,000 and provides 1,400,000 square feet of covered working space. Both of these figures seem tremendous but most astounding is the thought that they will be doubled with the new building project now under way.

Including parking space, this 242-acre Douglas plant at Long Beach is an industrial creation unlike any ever seen on this continent. The design and unusual construction were milestones in American ingenuity and skill. Records have been broken in many phases of its construction, for according to steel construction authorities, a feat unprecedented was the raising and riveting into place of 3763 tons of structural

steel in 32 days of working time, an average of 120 tons daily.

Long before its construction had reached its final stage and long before its formal dedication, major departments were set up and in operation, each marking another lap in the race against time. With walls and roofs to provide shelter, equipment and machinery was installed in buildings still under construction.

As the plant stands today with 7000 defense workers on its payroll and indications that this figure will soon be and ultimately quadrupled, we find a plant which incorporates construction techniques, defensive arrangements and production systems never before employed in the aircraft industry.

To a casual glance the exteriors of the buildings give no indications of the humming beehive within for there is to be found hundreds of skilled employes and scores of government representatives working in modern soundproofed offices. These structures are windowless and with light traps on the doors, thus making for complete invisibility at night. This is but a part of its unique "blackout" design. There are thousands of glareless fluorescent and mercury vapor lights which are never turned off. The buildings are fully air-conditioned making artificial weather at an installation cost of

FIRST OF ITS KIND. The October 1941 issue of the Douglas employee newsletter, *Airview*, featured several articles on the Long Beach aircraft plant, noting that the fortress-like, windowless walls of reinforced steel and its concrete design made the plant "the first U.S. project of its kind." The Long Beach "blackout" factory was conveniently located next to the Long Beach Municipal Airport and the Union Pacific Railroad. The plant was constructed to withstand air and bomb attacks. It was one of the largest built in the United States. The machinery inside the plant was specially designed to facilitate the new assembly-line type of aircraft production. (Copyright The Boeing Company.)

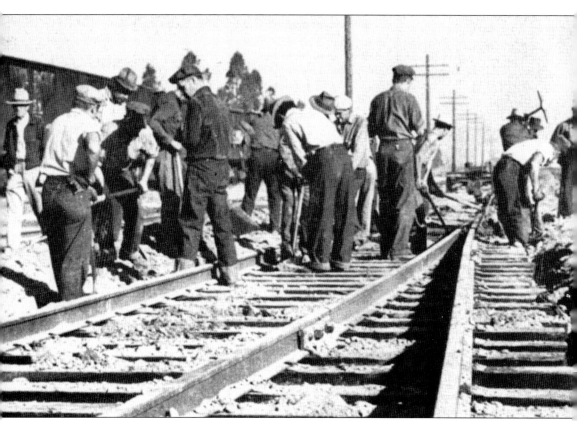

FIRST TASK. The first task performed after the groundbreaking ceremony was the construction of a railroad spur line that connected with the existing Union Pacific line adjacent to Cherry Avenue. The spur line allowed trains to go directly into the plant to haul the construction materials needed to build it. After construction was completed, the spur line provided access for additional materials and for the personal train of the president of the United States to visit the Long Beach plant in 1942. (Copyright The Boeing Company.)

9,000 TONS OF CONCRETE AND STEEL. Designed by Edward Cray Taylor and Ellis Wing Taylor, and built by P. J. Walker, the Long Beach plant was constructed of over 9,000 tons of concrete and steel. The initial plant was designed for the production of attack bombers and cargo planes at a cost to the U.S. Army of $12 million. Later a $13-million expansion allowed the plant to produce heavy, four-engine Flying Fortress bombers. The 1,422,350 square feet of working space was equal to the plants of Santa Monica and El Segundo combined. (Copyright The Boeing Company.)

HUGE ELECTRIC DOORS. Huge doors on ramps were electronically operated to allow for the movement of supplies and finished aircraft in and out of the buildings. When closed, the doors effectively sealed the plant buildings. Light traps on the doors made the buildings invisible at night. The fortress-like buildings were fireproof, equipped with high-speed sprinkling systems. All the buildings were fully air-conditioned with a $1-million system, the largest on the West Coast at the time. The air-conditioning was so powerful that precipitation often fell inside from the ceilings due to the moisture of the air outside. (Copyright The Boeing Company.)

UNDERGROUND TUNNELS AND VAULTS. Underground tunnels connected buildings and provided a safe passage for transporting materials and supplies between plant buildings. A 60-acre employee parking lot was constructed on the east side of Lakewood Boulevard with tunnels connecting it to the plant. Oil and gasoline supplies and strategic production materials were stored in underground vaults. Utilities and backup generators were also installed in underground vaults. The designers made certain that every aspect of the plant was bombproof and fireproof. (Copyright The Boeing Company.)

A NEW ERA OF AVIATION. A bi-wing can be faintly seen in the upper left flying over the construction of the Long Beach aircraft plant. This model of airplane would be quickly replaced by faster, sleeker planes produced at the Long Beach plant. (Copyright The Boeing Company.)

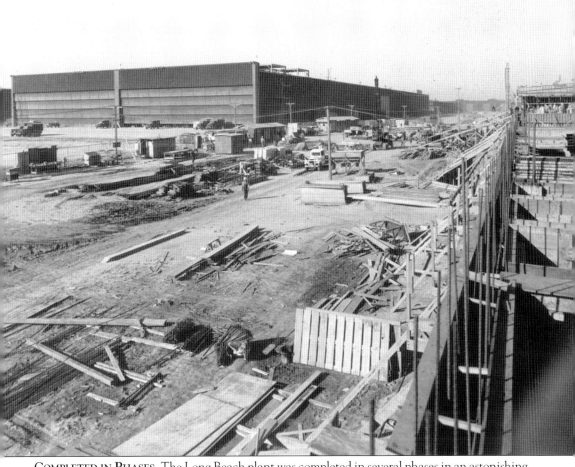

COMPLETED IN PHASES. The Long Beach plant was completed in several phases in an astonishing 20 months. Builders would raise and rivet 3,763 tons of structural steel in 32 days. On May 1, 1941, Building 6 was completed, followed in seven days by the completion of Building 8. The four-story administration building (Building 7) was finished on July 15, and Buildings 1 and 2 were completed 14 days later. The remainder of the buildings—12, 13, and the hangar, Building 15—were finished in the spring and summer of 1942. (Copyright The Boeing Company.)

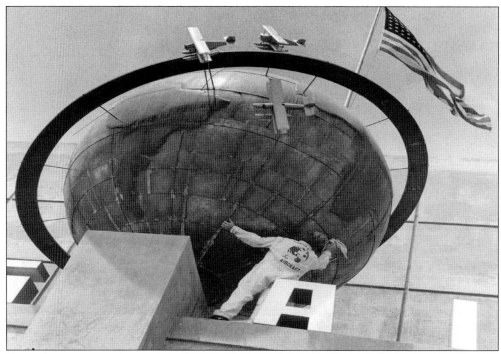

FIRST AROUND THE WORLD. The photograph above shows a worker putting the finishing touches on the Douglas Aircraft 12-foot copper globe atop the administration building. The globe, which served as the corporate logo of Douglas Aircraft, features replicas of the first Douglas plane—the Cloudster—and illustrates the company's theme: "First Around the World—First in Air Defense." In 1924, Douglas World Cruisers flown by U.S. Army pilots and crews circled the world for the first time by air. During the war, the entire aircraft plant and logo were covered in camouflage netting, as shown in the photograph below. (Both, Copyright The Boeing Company.)

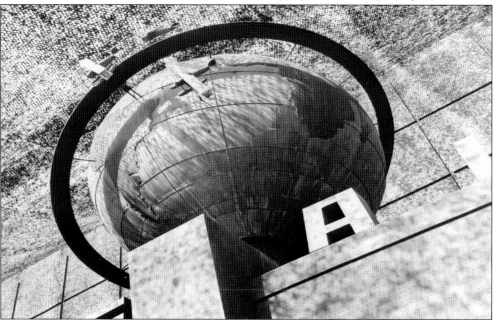

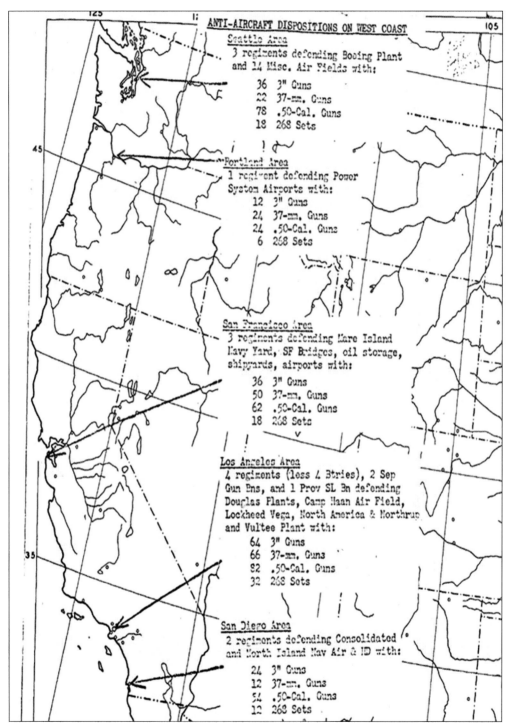

ANTI-AIRCRAFT DISPOSITIONS ON WEST COAST

Seattle Area
3 regiments defending Boeing Plant
and 14 Misc. Air Fields with:

 36 3" Guns
 22 37-mm. Guns
 78 .50-Cal. Guns
 18 268 Sets

Portland Area
1 regiment defending Power
System Airports with:

 12 3" Guns
 24 37-mm. Guns
 24 .50-Cal. Guns
 6 268 Sets

San Francisco Area
3 regiments defending Mare Island
Navy Yard, SF Bridges, oil storage,
shipyards, airports with:

 36 3" Guns
 50 37-mm. Guns
 62 .50-Cal. Guns
 18 268 Sets

Los Angeles Area
4 regiments (less 4 Btries), 2 Sep
Gun Bns, and 1 Prov SL Bn defending
Douglas Plants, Camp Haan Air Field,
Lockheed Vega, North America & Northrup
and Vultee Plant with:

 64 3" Guns
 66 37-mm. Guns
 92 .50-Cal. Guns
 32 268 Sets

San Diego Area
2 regiments defending Consolidated
and North Island Nav Air & ID with:

 24 3" Guns
 12 37-mm. Guns
 54 .50-Cal. Guns
 12 268 Sets

WEST COAST VULNERABILITY. This document illustrates the vulnerability of the West Coast because the area had most of the aircraft production capability for the U.S. military. Four military regiments equipped with anti-aircraft guns protected the three California Douglas plants, including Long Beach, during World War II. (Franklin Delano Roosevelt Digital Archives.)

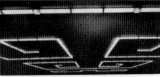

Let There Be LIGHT

No Gleam of Light Can Show Outside Long Beach Plant at Night; Inside, Modern Fixtures Make It As Bright As Day.

* THERE shall be light, decreed the builders of the blackout plant. Because they were designing the most modern airplane factory in the world these engineers demanded that the lighting be as last-minute as everything else at Douglas' amazing Long Beach factory.

And there was light . . .

Fourteen thousand fixtures and not a bulb in the place!

Mercury and fluorescent lamps have taken the place of the old incandescents which Edison invented and which you regularly snatch from the kitchen so that you can read your evening paper. Inside the great factory these lights in long tubes gleam 24 hours a day yielding the best illumination yet developed by electrical science.

The lighting system fits neatly into blackout plans. Not a glimmer leaks from the windowless buildings. Outdoor floodlights can be instantly doused by a single switch and replaced by dim blue lamps which provide enought glow for yard traffic but cannot be seen from the air.

Also in line with the general blueprint of defense from night bombing are the elaborate lighting systems and reserve generators. Like the regular transformers, these extra power supply units, capable of bearing the total lighting load of 5700 kilowatts, are buried deep underground in steel vaults.

The comfort and health of everyone working at the plant was the first consideration in designing the types and placement of all lighting. Fluorescents and vapor lamps were chosen because they provide far better illumination and place far less strain on the air-conditioning equipment than the hot glare of old-fashioned lights which use up more electricity producing heat than they do producing light.

Nine thousand high-intensity mercury vapor lamps illuminate* the production units. In the two final assembly buildings they are encased in glass prismatic reflectors spaced evenly 35 feet overhead. In exhaustively shops the lamps are lower, encased in glass steel diffusers and clustered close together, while in storage departments they are more widely spaced.

Offices in the administration and personnel-welfare buildings are equipped with daylight fluorescents. For the cafeteria a three tube ornamental design of fixtures hangs from the ceiling. Added to two daylight tubes is a pink one to assure a pleasant color combination.

Maintenance of the overhead lighting system in the shops is simplified by a network of three-foot catwalks installed in the steel rafters of the buildings. Fixtures may be safely pulled over to these catwalks for servicing without interrupting production on the floor.

Design and installation of lighting equipment at the blackout plant was directed by F. W. Conant, vice president in charge of manufacturing; L. N. Davis, director of plant engineering; Taylor and Taylor, architects and engineers; Walker Construction company, builders; and C. T. Gibbs, consulting electrical engineers.

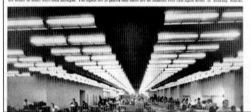

WEIRD PATTERNS are traced on the ceilings of office buildings by fluorescent lights, scientifically placed so that light is provided where and how needed.

BRIGHT AS DAY is the engineering department in the "blackout" plant. Men who work under the fluorescent lights say they are better in many ways than daylight. The lights are so placed that there are no shadows ever cast upon desks or drawing boards.

LET'S GO! U.S.A. KEEP 'EM FLYING!

BRIGHT AS DAY. The 1941 feature of the Douglas employee newsletter *Airview* explained to its readers that the Long Beach "blackout" factory was entirely windowless to prevent detection at night by enemy bombers. Fourteen thousand glare-less mercury and fluorescent light fixtures hung from the ceilings at varying heights and are reflected on the transparent noses of the deadly A-20 attack bombers lined up on the assembly floor in the photograph below. The vapor and fluorescent lights were utilized because they were cooler and consumed less electricity than incandescent bulbs. The lights were powered by massive transformers with backup power-supply units on standby in deep underground steel vaults. The lights could be quickly changed by accessing a network of three-foot catwalks located in the rafters of the plant. The lighting system was designed by F. W. "Ted" Conant, vice president of manufacturing. (Left, Copyright The Boeing Company; below, Franklin Delano Roosevelt Digital Archives.)

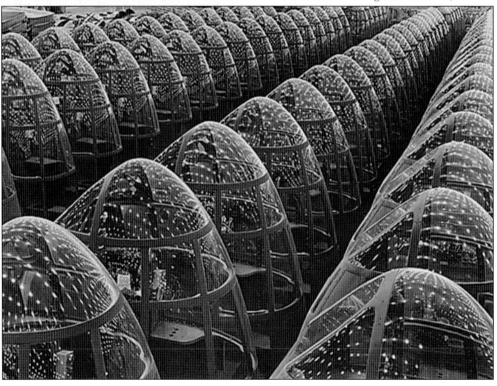

LIKE A HOLLYWOOD SET. Because of its location on the West Coast and its importance to the defense industry, elaborate steps were taken to disguise the Long Beach plant in order to lessen the chances of it being a target for enemy bombers. Douglas, whose other plant was located in Santa Monica near movie studios, used set designers to help with the design for hiding the true nature of its aircraft plants. Fake houses made of canvas and plywood, and chicken-wire-and-feather-mesh trees lined streets painted on the rooftops of the aircraft plant buildings, giving the appearance from the sky of a serene suburban setting. The remainder of the aircraft plant was covered in heavy camouflage netting and fortified by thousands of sandbags that ringed the buildings and the entrances to the many bomb shelters built for employees. On the right, Long Beach plant employees are shown taking their lunch break near one of the sandbagged bomb shelters. (Above, Copyright The Boeing Company; right, Library of Congress.)

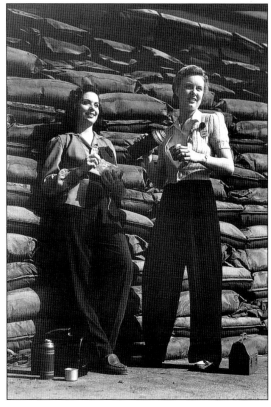

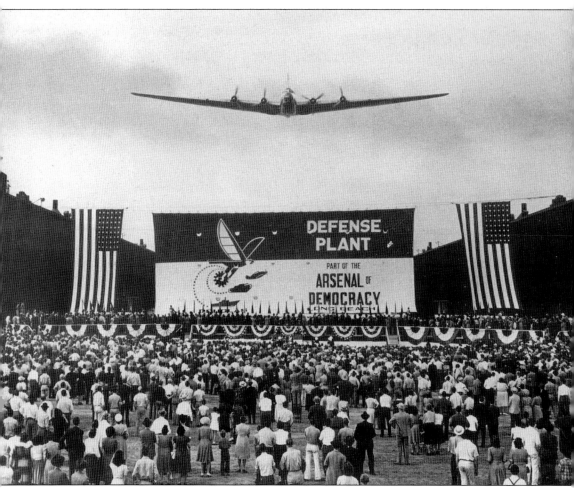

GREAT DAY FOR LONG BEACH. On October 17, 1941, more than 30,000 people watched as Lt. Col. Stanley M. Umstead, with Maj. Carl Cover, executive vice president of the Douglas Aircraft Company, at his side, piloted the Douglas B-19 *Guardian of a Hemisphere* bomber within 100 feet of the newly completed Douglas Aircraft Plant in Long Beach. The plane circled the crowd and returned for a second overhead display. The banner proclaiming the Long Beach defense plant as "part of the Arsenal of Democracy" hung between buildings and was, at that time, the largest banner ever made, measuring 100 by 40 feet. It weighed 600 pounds and took 50 gallons of paint for the lettering and designs; 625 feet of steel cable and 2,100 feet of rope supported it across the buildings. The two U.S. flags, weighing 50 pounds each and measuring 20 by 38 feet, hung with the stars facing east, as required by flag protocol. The Long Beach Municipal Band, lead by Dr. Herbert L. Clarke, provided music for the festivities. Numerous military and elected dignitaries attended the dedication of the Long Beach plant and dubbed it "a divine miracle." Speakers at the opening events included Long Beach mayor Francis Gentry and Camden Horrell, past president of the Long Beach Chamber of Commerce. Chamber president Richard Loynes presided over the dinner held at the Pacific Coast Club following the dedication ceremonies. (Copyright The Boeing Company.)

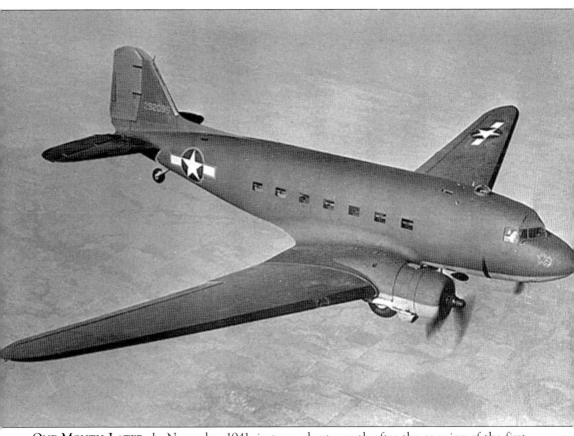

ONE MONTH LATER. In November 1941, just one short month after the opening of the first phase of the Long Beach Douglas plant, the first C-47 cargo plane rolled off the assembly line. During construction of the plant, materials and supplies had been delivered so that production of the mighty C-47 cargo plane could proceed. The C-47 Skytrain was a military adaptation of the commercial Douglas DC-3. It was modified to carry troops and cargo, and to tow troop-carrying gliders during combat. The U.S. Army Air Corps ordered 9,348 of these planes during the war. Pilots affectionately nicknamed the plane the "Gooneybird." The C-47 was considered by Gen. Dwight D. Eisenhower to have been one of the most important planes used to win the war. (Library of Congress.)

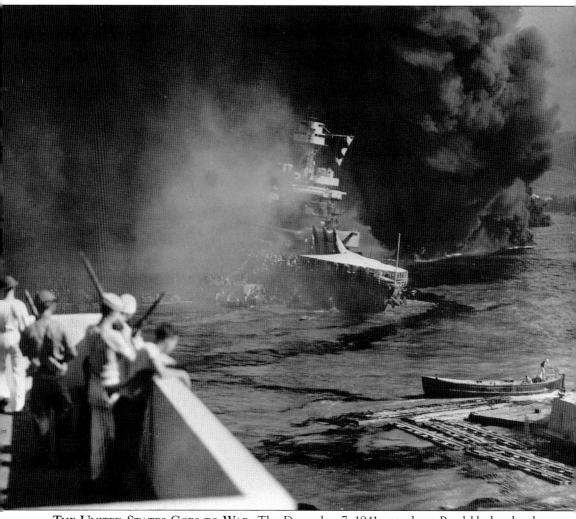

THE UNITED STATES GOES TO WAR. The December 7, 1941, attack on Pearl Harbor by the Japanese and the destruction of a large number of the ships of the U.S. Navy, such as the USS *California* shown in the photograph, thrust the United States into the war. Six months after the attack on Pearl Harbor, the Office of War Information (OWI) was established. Like its predecessor, the Department of Agriculture's Farm Security Administration, the OWI used propaganda to inspire patriotism in the American public. With most men away in military service, the need for defense workers intensified as the United States attempted to produce the ships, planes, and guns needed for the war, and the United States began recruiting women for defense jobs. (Library of Congress.)

Two

RECRUITING WOMEN WORKERS

RECRUITING WOMEN WORKERS. The OWI specifically produced exhibits to encourage women to leave their homes and to take jobs in the aircraft factories, shipyards, and munitions plants. The OWI also developed songs, movies, and radio programs and funded posters that appealed to women. An OWI "magazine guide" outlined the type of articles that were to be featured in popular women's magazines aimed at sending a message to women that it was important for them to work in the defense industries. Hundreds of OWI photographs were taken at the Douglas Aircraft Plant in Long Beach and were used for OWI posters and magazine articles. (NARA.)

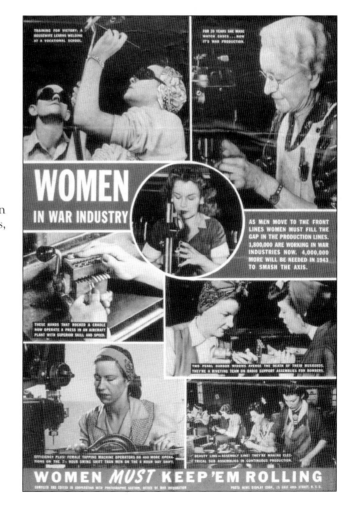

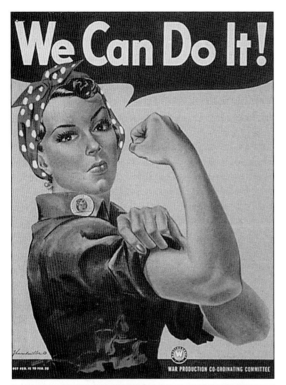

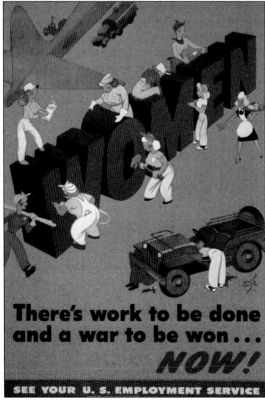

"WE CAN DO IT!" It wasn't until the 1970s, with the rise of feminism, that the "We Can Do It" poster was considered the iconic symbol of the more than 18 million women who worked in the defense industries during World War II and who were nicknamed "Rosie the Riveter." This 1940s poster was actually produced prior to the popularization of calling women war workers "Rosie the Riveter." Designed by J. Howard Miller, the poster was produced by the Westinghouse Company for its War Production Coordinating Committee, which was part of the U.S. War Production Board. Miller, who drew a series of propaganda posters for Westinghouse during World War II, based his drawing on a photograph of 17-year-old Geraldine Hoff, who appeared in a Michigan newspaper. Later the song "Rosie the Riveter," performed by the Vagabonds, popularized the image of women working in factories. Soon after, a *Saturday Evening Post* cover illustrated by Norman Rockwell featured a muscular, redheaded woman with a riveting gun strung across her lap and "Rosie" written on her lunch pail, forever branding the idea of "Rosie the Riveter" in American culture. (Both, NARA.)

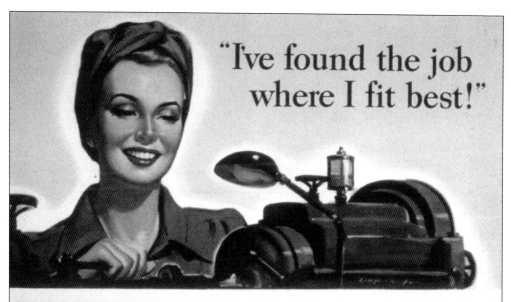

"I've found the job where I fit best!"

FIND YOUR WAR JOB
In Industry – Agriculture – Business

POSTERS EVERYWHERE. Almost every U.S. government agency used its resources to send messages to women that it was their duty to lend every effort possible to win the war. Posters were a popular way to communicate because they were inexpensive to produce and could be hung anywhere. The posters stressed that thousands of women were needed to "learn and work for Victory" and that the war could not be possibly won without them. With unemployment rates hovering around 15% after the Depression, many women welcomed the opportunity to earn wages outside of the home. The war changed societal attitudes that had traditionally limited the type of work acceptable for women. In 1940, approximately one out of every 20 workers was female. By 1944, the numbers increased to one out of five. (Both, NARA.)

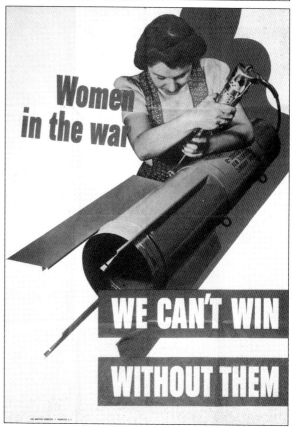

Women in the war

WE CAN'T WIN WITHOUT THEM

RECRUITING LONG BEACH TEACHERS. The Douglas Aircraft Plant received thousands of orders from the military for planes that needed to be produced in a short period of time. The seven-day, round-the-clock production required tens of thousands of employees, both full and part-time. Advertisements were placed in the local newspapers and the monthly journal of the City of Long Beach Teachers Club to recruit teachers (mostly women) who wanted to earn extra money. The Long Beach City Schools operated round-the-clock training classes in welding and aircraft mechanics so that students could take jobs at Douglas. High school youths over the age of 16 were only allowed to work at the Long Beach Douglas plant on the 3:30 p.m. or 8:00 p.m. short shift and had to attend four hours of regular class during the day. Teachers were encouraged to work a four-hour "Victory Shift" after school. (Copyright The Boeing Company.)

RECRUITING LOCALLY. Douglas Aircraft employed an extensive staff of writers, photographers, and graphic designers to produce billboards, advertisements, photographs, training films, and publications to assist the war production drive. Billboards appeared throughout the Los Angeles area and were used to recruit Hispanic men and women to work in the three Douglas plants. Douglas operated 18 employment offices in Los Angeles and Orange Counties that accepted applications six days a week. (Copyright The Boeing Company.)

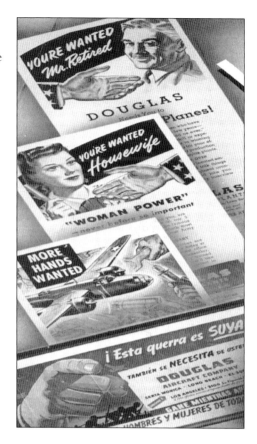

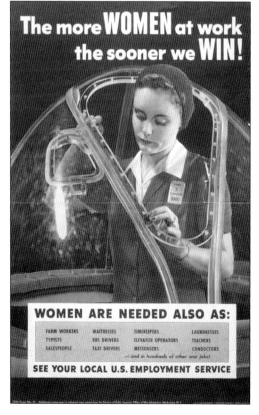

RECRUITING NATIONALLY. The Office of War Information utilized the Long Beach plant to shoot photographs of models who posed as workers assembling bombers. The poster on the left shows an attractive model working inside the bubble-style, shatter-proof, Plexiglas B-17F bomber nose. The actual bomber nose, when completed, would contain a .50-caliber machine gun. The glamorous image of women working in factories was promoted but conflicted with the harsh reality of the factory floor. The model is wearing make-up and jewelry, which was contrary to Douglas employee rules prohibiting rings and wristwatches. Actual Douglas female employees were cautioned in employee publications not to let "glamour interfere with your work." (NARA.)

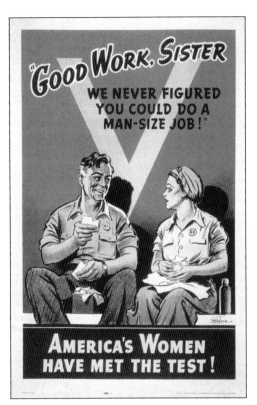

"GOOD WORK, SISTER WE NEVER FIGURED YOU COULD DO A MAN-SIZE JOB!"

AMERICA'S WOMEN HAVE MET THE TEST!

SOLDIERS OF SUPPLY. Women defense workers were referred to as "soldiers of supply" as part of the propaganda effort to attract women to defense work. Noticeably absent from the posters were depictions of the many African American men and women employed in the plants. (NARA.)

APPEALING TO MARRIED WOMEN. The posters also made an emotional appeal to married women who, at the start of the war, were reluctant to take jobs outside of the home. By 1943, the defense industry faced a critical shortage of workers, making the recruitment of unemployed housewives important to meeting production goals set by the military. The recruitment campaign was successful. By 1944, married women and women over the age of 35 entered the workforce in greater numbers than their younger, single sisters. (NARA.)

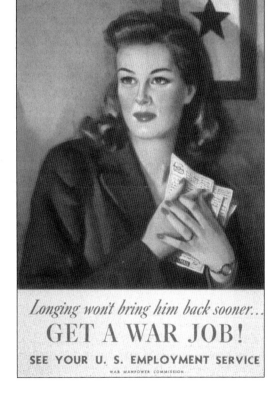

Longing won't bring him back sooner... GET A WAR JOB! SEE YOUR U. S. EMPLOYMENT SERVICE

WAR MANPOWER COMMISSION

Boy Scouts Seeking War Workers

In Whirlwind Offensive Lads Again Come to Nation's Aid

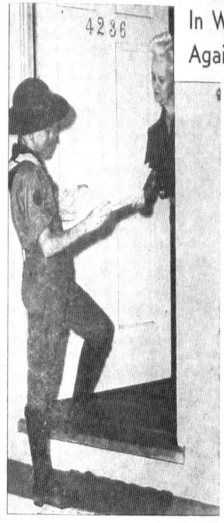

A determined and well-organized army of 6,000 Boy Scouts today open a whirlwind offensive all their own on the war production front.

Volunteering to help war industry find the new employes needed so desperately, troops of "Victory Scouts" in the Santa Monica, Long Beach and Orange County areas will make a house-to-house canvass to seek men and women available for employment in aircraft plants.

Under the sponsorship of the Boy Scouts of America, in cooperation with the Employe-Management War Production Drive Committees of the Douglas Aircraft company, the drive will continue through September 6.

Wearing handsome arm bands as identification, the "Victory Scouts" will visit hundreds of thousands of homes to describe the urgent need for additional men and women on war production lines. They will leave cards that introduce applicants to Douglas Aircraft employment offices in Southern California and assure them speedy and courteous consideration.

Have Fine War Record

Outstanding success of the Scouts in this new and important undertaking was indicated by their achievements in previous campaigns to aid the war effort. During the recent rubber and scrap metal drives, these same troops collected hundreds of tons of essential materials.

Although the spirit and enthusiasm of the young patriots needed no additional incentive, the Douglas Employment-Management Committees in appreciation have offered a $500 United States war bond to the troop in each area concerned which refers the largest number of applicants to Douglas employment offices. This winning troop in each area will have another stake in victory, too, for a huge Douglas warplane will have their troop number and city painted on its nose. The Scouts will pose for

SCOUTS SPREAD THE NEWS—Scout Stevens Wright hands a copy of the Special Boy Scout edition of the Douglas Airview News to interested housewife, Mrs. Rachel Abrams. Stevens is the fourth member of an otherwise all-Douglas family, which includes his father, Wallace Wright, first shift, his mother, Olga Wright, third shift, and his sister, Pat Wright, first shift, all helping build Douglas planes.

VICTORY SCOUTS IN LONG BEACH. Douglas Aircraft utilized local Victory Scouts—Boy Scouts who would canvass house-to-house to seek men and women available for employment at the Long Beach plant. The effort was coordinated by the Douglas Aircraft Employee-Management War Production Drive Committee. Scouts handed out flyers that told of the available jobs and the places at which to apply. The Scout troop recruiting the most workers received a $500 U.S. Bond. (Copyright The Boeing Company.)

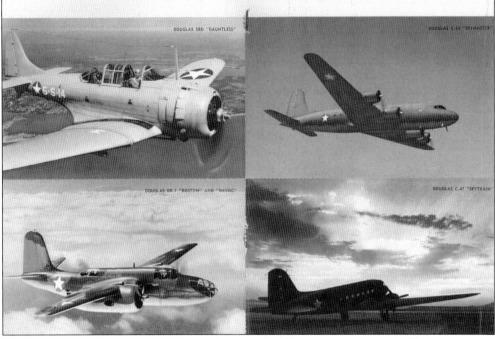

DOUGLAS SBD "DAUNTLESS"

DOUGLAS C-54 "SKYMASTER"

DOUGLAS DB-7 "BOSTON" AND "HAVOC"

DOUGLAS C-47 "SKYTRAIN"

POSTCARDS FROM THE PLANT. Recruitment booklets from Douglas Aircraft included a series of penny postcards (the required amount of postage) with colorful photographs of "some of the airplanes you'll help build at Douglas." The postcards depict the SBD Dauntless, which was the core of the U.S. Navy air operations in the Pacific, as well as the C-54 Skymaster, the DB-7 Boston/Havoc, and the C-47 Skytrain. Later production shifted to the B-17 Flying Fortress through a joint effort with the Boeing Company. (Copyright The Boeing Company.)

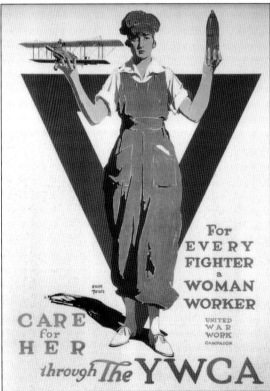

For EVERY FIGHTER a WOMAN WORKER

UNITED WAR WORK CAMPAIGN

CARE for HER through The YWCA

YWCA. The Long Beach Young Women's Christian Association (YWCA) was located at Sixth Street and Pacific Avenue, and provided 100 rooms for female workers. The national YWCA joined the effort of encouraging women to take jobs in the war industries. (Long Beach Airport Archives.)

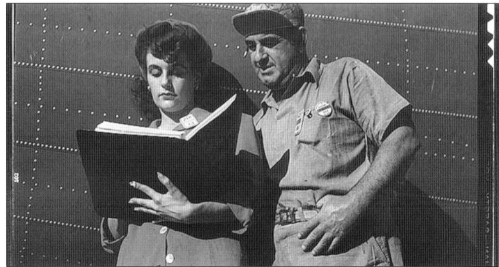

EVERYONE IS NEEDED. JOB TRAINING

This is EVERYONE'S war. Gallant Americans on battlefronts everywhere are fighting in liberty's cause, but they must have more and MORE bomber and transport airplanes IF they're to do their job. WE at home MUST build these aircraft and build them NOW!

To meet the demands of our fighting forces, Douglas Aircraft urgently needs *thousands* of men and women, skilled and unskilled. Willingness to learn and work for Victory are the principal requirements.

Because the biggest production job in history has to be done, EVERYONE WILL BE CONSIDERED and most applicants can be placed immediately.

Vic and Val typify Douglas workers who are VALiantly pulling together toward VICtory. As you read this booklet, you'll see some of the things they're doing that you, too, can do. We think you'll like them and feel certain you'll want to join them.

If you sincerely want to do more for the war effort but can't quite make up your mind whether you "belong" in factory work, you need not hesitate longer. Douglas Aircraft staffs thousands of Government certified instructors under whom you will train. Thus you will be able to adapt yourself quickly to whatever job you are assigned.

Every minute of your training will be a real adventure because the trade you'll learn is of vital importance to your country's welfare and holds a promising future for YOU.

You are paid regular wages right from the start. If a career in aviation is your goal, at Douglas you will be working for the leader, in peace as in war.

EVERYONE IS NEEDED. Douglas Aircraft changed the process by which aircraft were built. By converting from the slow "job shop" methods of producing aircraft one-by-one, to an assembly-line system that allowed mass production, Douglas Aircraft was able to produce a single aircraft in a matter of hours. This mass production system required thousands of workers who could be easily trained to assemble parts and subassemblies. Douglas Aircraft publications stressed that women could find their place in the plant by the side of men, doing the same work. The drawings shown above are from the Douglas "Win With Wings" booklet that was given to prospective workers. The men are referred to as "Vic" and the women as "Val," and both are standing side by side, working toward victory. Many of the photographs released by Douglas Aircraft show men and women working side by side, producing military aircraft. (Above, Copyright The Boeing Company; below, Library of Congress.)

IT'S JUST LIKE HOUSEWORK. Douglas Aircraft boasted in its wartime recruitment pamphlets that more than half of its production employees were wives, mothers, and sweethearts of men in military service who were "doing something REAL to bring their loved ones home sooner." Drawings helped promote the theme that many of the Douglas jobs were relatively similar to tasks performed daily "about the home." For instance, one pamphlet explained: "operating a stamping machine is not unlike cutting cookies; many sewing tasks are no more difficult than mending junior's pants; painting aircraft parts is just as simple as applying a new coat of paint to the porch furniture; polishing and waxing are skills you already possess; sorting and checking are familiar household chores." (Above, Copyright The Boeing Company; below, Library of Congress.)

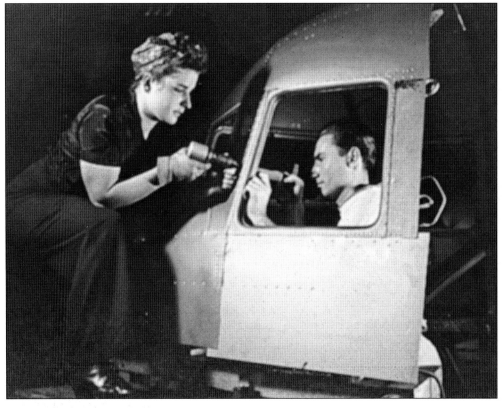

TOOLS FOR WORK. The Douglas Aircraft employee booklet for prospective female workers pointed out that some of the tools needed to make aircraft were simple and lightweight. The booklet reminds readers that the rivet gun, which was also referred to as the "Buck Rogers" because of its futuristic look, weighed only three and a half pounds, or about "half the weight of the average household iron." Plant workers were required to purchase toolboxes and the hand tools needed to do their jobs from the company store or the local hardware store. Women had to make due with tools (and gloves and goggles) that were manufactured for the larger male worker. (Right, Copyright The Boeing Company; below, NARA.)

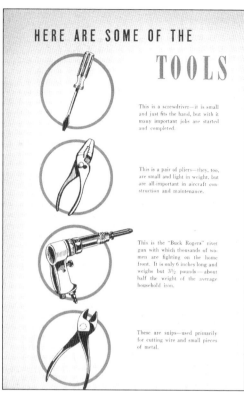

HERE ARE SOME OF THE

TOOLS

This is a screwdriver—it is small and just fits the hand, but with it many important jobs are started and completed.

This is a pair of pliers—they, too, are small and light in weight, but are all-important in aircraft construction and maintenance.

This is the "Buck Rogers" rivet gun with which thousands of women are fighting on the home front. It is only 6 inches long and weighs but 3½ pounds—about half the weight of the average household iron.

These are snips—used primarily for cutting wire and small pieces of metal.

WEAR YOUR GOGGLES
or choose your glass eyes
while you can SEE THEM!

8% OF ALL NAVY ACCIDENTS ARE EYE INJURIES

DESIGNS FOR DUTY

Women's work fashions have gone to war, too. Women can now really look chic and trim in the new streamlined outfits designed specifically for feminine war work. These garments are made to insure work comfort, freedom of movement and eye appeal. They are smartly tailored of cotton twill or rayon celanese and launder easily. Trouser creases are stitched to simplify pressing. When you select your war worker's outfit, be sure to look for these striking new "Designs for Duty." They are being shown at all better stores.

DESIGNS FOR DUTY. Douglas Aircraft publications reminded potential female employees that they could look "really chic and trim" in the outfits specifically designed for "feminine war work." Women were warned, however, not to wear wristwatches, pendant earrings, necklaces, bracelets, and rings. Women were also discouraged from wearing loose sleeves, ties, frills, lapels, and cuffs. Most women working in factory jobs wore men's pants or overalls and whatever blouse and sensible low-heeled shoes they had in their closet. Only secretaries, women counselors, and nurses wore skirts in the plant. As more women entered the workforce, specifically designed work clothing—"designs for duty"—became available "in all the better stores in Long Beach." (Both, Copyright The Boeing Company.)

SAFE SHOES AND CLOTHING. The Office of War Information produced a series of photographs that were distributed for use by defense employers. These photographs illustrate the types of safe shoes (with box toe) and clothing women workers should wear. On the factory floor, pant legs were buttoned above the ankle to prevent them from being snagged on equipment. Women were instructed to wear pants that were trim and free of pleats and ornamentation. During the war, the War Production Board prohibited cuffs on any pants because the extra material was considered wasteful. (Library of Congress.)

UNSAFE HAIR. The OWI used these before-and-after photographs to show women how to change their hairstyle from wild and disheveled to smooth and controlled. Uncovered and loose hair was a constant danger near machinery and a violation of work safety rules. Additionally, drops of oil and grease and metal shavings could be lodged in uncovered hair. Women were encouraged to wear heavy cotton or rayon mesh hairnets, plastic caps, bandannas, or snoods, which completely covered the hair. (Both, Library of Congress.)

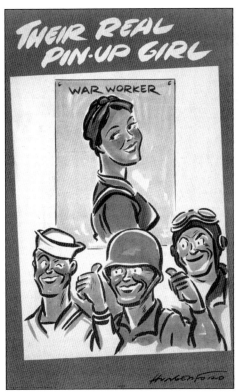

READY FOR WORK. Posters and photographs featuring women with covered hair, gloves, and safety goggles in place sent the strong message of how women should look when they reported for work. While the propaganda glamorized these war workers' outfits, many women complained that when they wore pants they were treated differently by both men and women. Women workers told stories of how some men thought they were "loose" because they wore pants, pointing out that their male co-workers would look them over with a special focus on their "empennage"—a term for the tail assembly of an airplane. Pant-wearing women noticed that they were often called "Baby" or "Sister" if they did not change into skirts or dresses before going home. Long Beach police had to be called out to escort women workers who were being harassed while trying to get home by bus. (NARA and Library of Congress.)

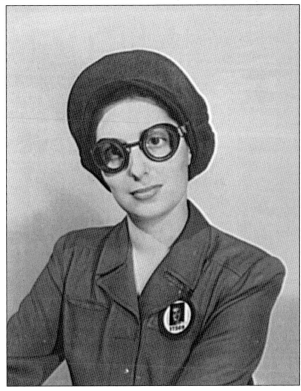

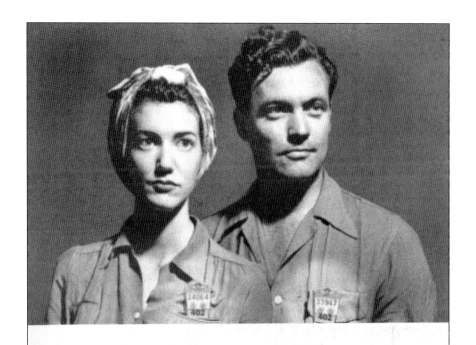

A BADGE OF HONOR

Even as uniforms and insignia identify men and women in our military service, so the Douglas employe badge marks patriotic Americans who today lead the nation in volume and types of combat, cargo and transport aircraft produced.

Just re-designed, the Douglas badge has a distinctive simplicity and dignity worthy of the craft it represents. Wings have been given to the familiar "First Around the World" trade mark, a symbol of Douglas and a quick identification of the wearer. The Douglas badge identifies your plant, department and shift. We believe you will wear it with pride. It signifies that YOU are a worthy member of a great and needed production army.

A BADGE OF HONOR. Defense industry workers were fingerprinted and photographed during the application process. Married women had to provide their marriage license. Once hired, workers were given an identification badge and identification card that indicated the worker's number, plant, department, and shift. Badges were color coded by plant and made of plastic because of the shortage of metal. Long Beach's plant color was yellow. Badges had to be worn at all times in plain view on the left side, chest high on the outer garment. Workers were sent home if they came to work without a badge. Loaning or losing the badge or identification card could subject the worker to penalties under the Espionage Act. (Copyright The Boeing Company.)

HERE
ARE
SOME
OF
THE
OBS

VAL

GENERAL ASSEMBLER—A general assembler puts things together. This job is truly the biggest and most important part of the actual building of aircraft. When you become an expert assembler, you may be given the opportunity to set-up assemblies or develop assembly work.

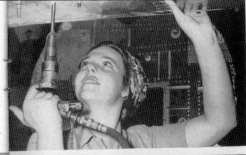

SAW OPERATOR—A saw operator prepares metal for airplane fabrication by cutting lengths, forming angles, and making slots. You will learn to use a circular, a radiac, or a cut-amatic saw, and you'll learn how to select the kind of blade according to materials to be used and type of cut to be made. You will also learn how to tilt the blade to the proper angle and to read directions from blueprints.

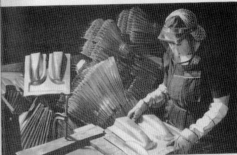

SHEET METAL WORKER—Sheet metal workers are real artisans. They perfect parts that cannot be finished by other operations. To learn to be a sheet metal worker, you check, form and straighten sheet metal parts; learn the use of various hand tools, form blocks, templates, and some shop mathematics. After you have mastered your job and have become proficient, you may make layouts or even develop parts from blueprints and loft templates.

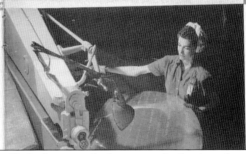

JOBS FOR WOMEN. Because women traditionally had not worked in aircraft plants and were unfamiliar with the types of jobs available to them, the Douglas Aircraft Company produced pamphlets that provided photographs and descriptions of these jobs. Workers were assigned to a group in a department headed by a supervisor who was assisted by a foreman. Assignments were made in Engineering, Material and Tooling, Quality, Manufacturing, or Inspection. Other areas

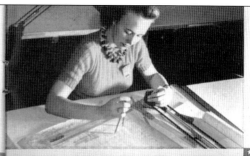

TOOL DESIGNER—If you have artistic inclinations and have had algebra and plane geometry in high school, take advantage of the opportunities awaiting you as a tool designer. We have worked out a program by which you will learn about tools, machines, descriptive geometry, and elementary drafting.

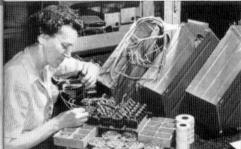

ELECTRICAL ASSEMBLER—An electrical assembler runs color-coded wiring around wooden pegs on an assembly jig, shellacks the wire bundles, tapes them and fastens terminals to wire ends. These wires are drawn into the airplane and connected to junction boxes and switches by the electrician who installs the wire bundles. This work is checked several times by inspectors as the work progresses.

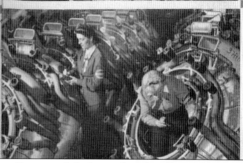

INSPECTOR—There is nothing subtle about the title of Inspector — they inspect things, such as materials and parts. Everything that goes into an airplane must be inspected for safety—pulleys, molded rubber goods, nuts, bolts, screws, cotter pins, forgings, turnbuckles, sheet metal, tires, wheels, tubes, tubing, wiring, rivets, glass, castings, and thousands of other parts. After simple instruction, you should quickly learn what to look for, where, why, and how.

included Plant Engineering, Motor Transportation, Personnel, Industrial and Public Relations, Comptroller (Finance), Legal, Plant Protection, and Welfare. While some considered their jobs to be only for the duration of the war, other women planned to stay in the workforce at jobs that paid considerably more than traditional female jobs. (Copyright The Boeing Company.)

In a field usually reserved for men y, Jane Little has become the first man at the Douglas Long Beach plant attain the title of "professional eneer."

Jane started work in the tracing group the Douglas war plant, later spending years as a leadwoman on the famed 47 Skytrain line working with hyulics. Now she has attained the at desire of her childhood to be an gineer, and her present war job is ncerned primarily with designing.

At right, she takes notes on construc- n of a *Flying Fortress* tail-gunner's kpit, looking very decorative.

Graduated from U.C.L.A. with a B.S. gree in 1940, Jane studied mathetics, psychics and chemistry. Jane ered college at 15 and credits her ther with having given her excellent sic training in mathematics.

Also an athlete of note, Jane won the tional Intercollegiate 100 yards ast stroke in the same year. She is lifornia State Table Tennis champion d was a finalist for the past three ars in the Long Beach City tennis rnament. Persistence seems to be e's recipe for success both in sports d engineering, for she says that next r she plans to be the winner.

When questioned on postwar plans, Jane left little room for doubt as to her intentions. "Of course I shall con- tinue my work in engineering," she re plied, "if not in the aircraft industry then in the automotive field."

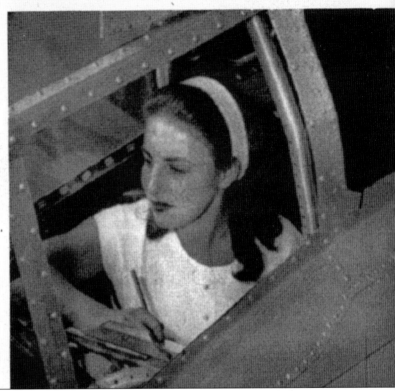

PROFESSIONAL POSITIONS. Women with college degrees had little job opportunities outside of teaching. Douglas Aircraft highlighted the few women it employed in professional jobs, including Jane Little, who became the first professional engineer at the Long Beach plant. While the photograph and article tout Little's accomplishments, it also notes her appearance as "looking very decorative." (Copyright The Boeing Company.)

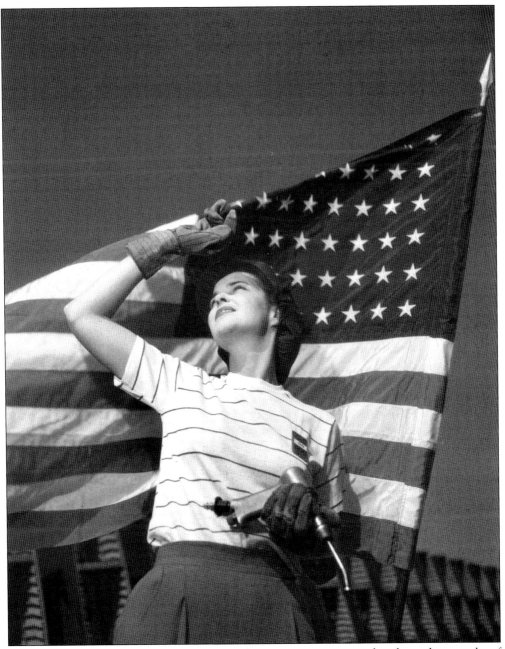

LONG BEACH "ROSIE." Douglas Aircraft took every opportunity to distribute photographs of women to new arrivals, commending the women workers as "doing a pretty good job of driving rivets and mastering the thousand-and-one other tasks necessary to the production of airplanes in war." (Copyright The Boeing Company.)

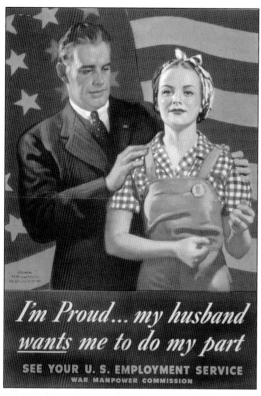

I'm Proud... my husband wants me to do my part

SEE YOUR U. S. EMPLOYMENT SERVICE

WAR MANPOWER COMMISSION

SHORTAGE OF WORKERS. Throughout the war, propaganda continued, aimed at getting women into defense jobs. Douglas Aircraft faced serious shortages of workers as the military increased its orders for planes. The California Shipyards in Long Beach also needed 11,000 workers to meet its production goals. (Both, NARA.)

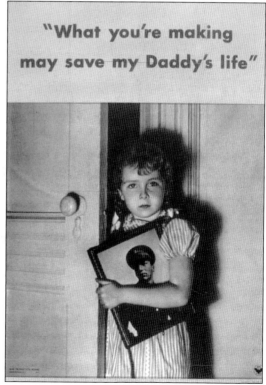

"What you're making may save my Daddy's life"

Three

ROSIE COMES TO LONG BEACH, CALIFORNIA

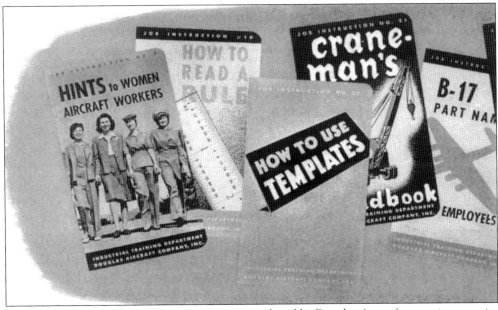

HINTS TO WOMEN AIRCRAFT WORKERS. Women hired by Douglas Aircraft were given a series of publications specifically focusing on plant work from the female perspective. Douglas produced training films, posters, and publications through its Industrial Training Department. A series of job instruction booklets for its new female workers, including No. 9, "Hints to Women Aircraft Workers," instructed women workers on how to avoid mental and physical fatigue in their new jobs building planes. "You will find it different from housework or other jobs," the booklet reminded, departing from the Douglas Aircraft recruitment pamphlet that told potential applicants of the similarity between aircraft production and housework. (Copyright The Boeing Company.)

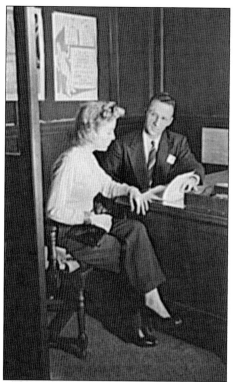

LEARNING WHAT TO WEAR. Women who had not worked outside of the home or who had not worked in traditionally male jobs in plants and factories were not accustomed to the clothing and other requirements of these jobs. Most women were not accustomed to wearing slacks in public. The female employee pictured on the left is being counseled about the need to replace her open-toed shoes with a more practical, safer pair. (Library of Congress.)

WOMEN COUNSELORS. Wartime employers like Douglas Aircraft utilized counselors to talk with women employees about the appropriate clothing, shoes, and hairstyles needed to work on the factory floor. Douglas Aircraft advertised to prospective employees that it hired female employee counselors on each shift who were on hand to help women workers with "problems of a feminine nature—either job or personal." Pictured on the left is Claudia N. Wooldrige, a Douglas women's counselor at the Long Beach plant. Pictured on the right is an unidentified counselor. (Copyright The Boeing Company.)

ASSEMBLY LINE LOVELIES. The realities of working in a factory or aircraft plant meant difficulties in cleaning machine grime off of hands, fingernails, noses, ears, hair, and clothing. Although plant lore stated that the dirtier the woman's clothing, the more the supervisor knew how hard she was working, women were faced with propaganda that encouraged them to "stay fresh and clean." On one hand, the Douglas publications acknowledged that women should take "dirty male jobs," while at the same time, these female employees were bombarded with articles on how these "assembly line lovelies" can stay "fresh-appearing, neat and attractive." Douglas Aircraft even provided a cream, "Pro-tex," that women could smear over their hands to keep grease and oil from embedding into the skin and nails. Most women found that the cream did not work and made it difficult to completely clean their hands and nails. The frequent washing of hands with harsh factory soap dried and cracked hands, exposing them to dermatitis. (Copyright The Boeing Company.)

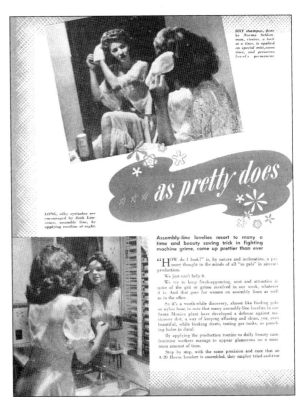

DRY shampoo, done by Norma Schlottman, riveter, a lock at a time, is applied on special mitt, saves time, and preserves lovely permanent.

LONG, silky eyelashes are encouraged by Beth Lawrence, assembly line, by applying vaseline at night.

as pretty does

Assembly-line lovelies resort to many a time and beauty saving trick in fighting machine grime, come up prettier than ever

"HOW do I look?" is, by nature and inclination, a primary thought in the minds of all "us gals" in aircraft production.

We just can't help it.

We try to keep fresh-appearing, neat and attractive in spite of the grit or grime involved in our work, whatever it is. And that goes for women on assembly lines as well as in the office.

So it's a worth-while discovery, almost like finding gold or nylon hose, to note that many assembly-line lovelies in our Santa Monica plant have developed a defense against machinery dirt, a way of keeping alluring and clean, yes, even beautiful, while bucking rivets, testing gas tanks, or punching holes in dural.

By applying the production routine to daily beauty care, feminine workers manage to appear glamorous on a minimum amount of time.

Step by step, with the same precision and care that an A-20 Havoc bomber is assembled, they employ tried-and-true

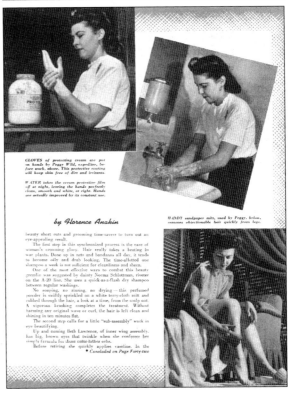

GLOVES of protecting cream are put on hands by Peggy Wild, expediter, before work, above. This protective coating will keep skin free of dirt and irritants.

WATER takes the cream protective film off at night, leaving the hands perfectly clean, smooth and white, at right. Hands are actually improved by its constant use.

HANDY sandpaper mitts, used by Peggy, below, removes objectionable hair quickly from legs.

by Florence Anakin

beauty short cuts and grooming time-savers to turn out an eye-appealing result.

The first step in this synchronized process is the care of woman's crowning glory. Hair really takes a beating in war plants. Done up in nets and bandanas all day, it tends to become oily and drab looking. The time-allotted one shampoo a week is not sufficient for cleanliness and sheen.

One of the most effective ways to combat this beauty gremlin was suggested by dainty Norma Schlottman, riveter on the A-20 line. She uses a quick-as-a-flash dry shampoo between regular washings.

No soaping, no rinsing, no drying — this perfumed powder is swiftly sprinkled on a white terry-cloth mitt and rubbed through the hair, a lock at a time, from the scalp out. A vigorous brushing completes the treatment. Without harming any original wave or curl, the hair is left clean and shining in ten minutes flat.

The second step calls for a little "sub-assembly" work in eye beautifying.

Up and coming Beth Lawrence, of inner wing assembly, has big, brown eyes that twinkle when she confesses her simple formula for those come-hither orbs.

Before retiring she quickly applies vaseline. In the
• Concluded on Page Forty-two

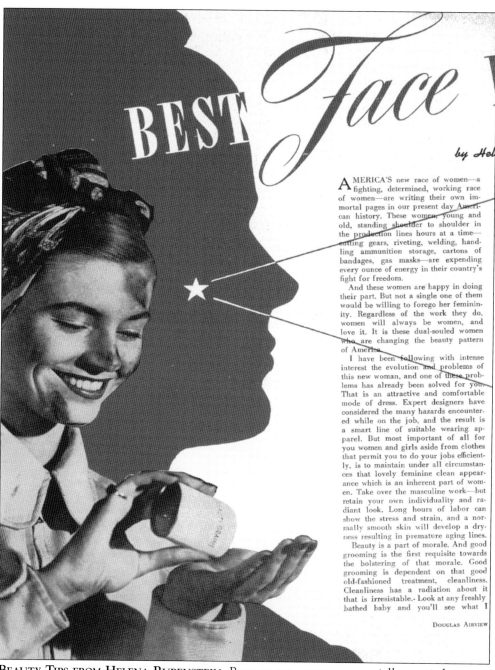

BEST *Face*

by Hel

A MERICA'S new race of women—a fighting, determined, working race of women—are writing their own immortal pages in our present day American history. These women, young and old, standing shoulder to shoulder in the production lines hours at a time—cutting gears, riveting, welding, handling ammunition storage, cartons of bandages, gas masks—are expending every ounce of energy in their country's fight for freedom.

And these women are happy in doing their part. But not a single one of them would be willing to forego her femininity. Regardless of the work they do, women will always be women, and love it. It is these dual-souled women who are changing the beauty pattern of America.

I have been following with intense interest the evolution and problems of this new woman, and one of these problems has already been solved for you. That is an attractive and comfortable mode of dress. Expert designers have considered the many hazards encountered while on the job, and the result is a smart line of suitable wearing apparel. But most important of all for you women and girls aside from clothes that permit you to do your jobs efficiently, is to maintain under all circumstances that lovely feminine clean appearance which is an inherent part of women. Take over the masculine work—but retain your own individuality and radiant look. Long hours of labor can show the stress and strain, and a normally smooth skin will develop a dryness resulting in premature aging lines.

Beauty is a part of morale. And good grooming is the first requisite towards the bolstering of that morale. Good grooming is dependent on that good old-fashioned treatment, cleanliness. Cleanliness has a radiation about it that is irresistable.- Look at any freshly bathed baby and you'll see what I

DOUGLAS AIRVIEW

BEAUTY TIPS FROM HELENA RUBENSTEIN. Because some women, especially married women, were reluctant to take traditionally male jobs, defense employers such as Douglas Aircraft waged an aggressive campaign in recruitment and employee publications stressing that the women who worked at these jobs were happy to do their part "but not a single one of them would be willing to forego her femininity." Douglas Aircraft utilized beauty experts such as Helena Rubenstein to write articles in the employee newsletter to remind the female worker that while she can "take over the masculine work," she needed to "retain her individuality and radiant look." (Copyright The Boeing Company.)

DUAL-SOULED WOMEN. Douglas Aircraft publications referred to its women workers as "dual-souled," working their shifts in grime and grease and then going home to become glamorous once again. The image portrayed was often not what occurred. The shifts were long and exhausting. Many women experienced physical problems directly associated with their plant work. Pressing vibrating rivet guns against the upper part of the body or abdomen caused injury to the breasts and the abdomen. Menstrual irregularity and discomfort were also frequent complaints of the women, who stood for hours while performing difficult physical work. Women also became dehydrated or faint from failing to drink or eat properly. Some developed the "aircraft worker's slouch" from having to work for long hours bending over or working in cramped spaces. (Copyright The Boeing Company.)

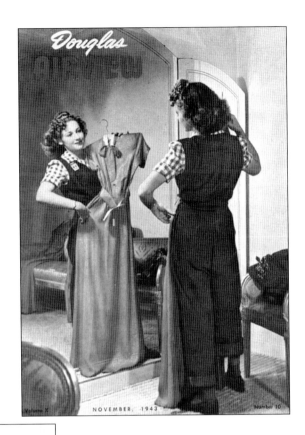

NOVEMBER, 1943

MATRONS

You will find a group of competent matrons ready to help you when you're ill or when an emergency arises. They are on duty on each shift in the rest rooms to...

- Give you aspirin and soda tablets whenever needed. (Also obtainable from your supervisor.)

- Sew on buttons and mend hems.

- Help you to the dispensary when ill.

- Do a thousand and one other things for you.

If you cannot find a matron in the restroom, call the Matron's Office. The telephone number is listed in all rest rooms.

COMPETENT MATRONS. Douglas Aircraft provided "competent matrons" who were stationed each shift in the Douglas Aircraft Plant restrooms to assist women workers when ill or when an emergency arose. Matrons were on hand to give out aspirin and soda tablets, to sew on buttons and mend hems, to help women to the dispensary when ill, and to "do a thousand and one other things" for them. (Copyright The Boeing Company.)

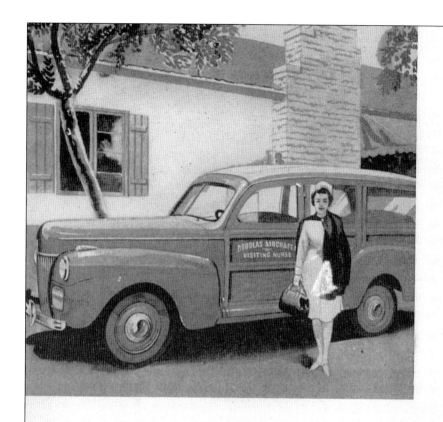

Partners

◀ No THRONG of robots are the men and women of Douglas. Though their numbers are great, so is their individuality of character and living. They fight the battle of production through no tyrant's decree. They fight because it is their battle—and they fight it well and hard.

Between employes and management there is no barrier and no gap. There are common bonds of personal understanding, of unity and loyalty, for the factory manager, the riveter, the engineer and the mechanic are partners. They fight in the same cause on the same front line.

How the great family lives and works together day by day is a drama of human experience that includes everything in this book and more. It is a drama of personal things like gold service pins, personnel counselors, dispensaries and visiting nurses. Only the little, human things can make a family.

THIS IS 🌐 OUR STORY

ON-SITE MEDICAL CARE AND VISITING NURSES. Donald Douglas provided care at on-site medical clinics at the aircraft plants to his workers who became ill or injured on the job. Visiting nurses were often sent to the employee's home as one of the "little, human things that can make a family." In return for paying a small monthly payment to the Aircraft Workers Medical Plan, employees could also receive medical care for non-industrial injury or illness from a network of doctors and hospitals in Southern California. Donald Douglas was a firm believer in a healthy workforce and made certain that numerous pamphlets on proper eating and the importance of vitamins were distributed to aircraft plant workers. (Copyright The Boeing Company.)

Thoughts of a Defense Worker

Dept. 293-7

I am a defense worker. There are thousands just like me through our great nation. To me, it is the most wonderful experience of my life—because the nature of the work is so far reaching.

Sometimes—when energy is low, the task seems heavy and wearisome, and I find my mind wondering to thoughts of fishing, golf, swimming, boating, or perhaps just resting on the beach. My mind seeks such thoughts as—"if I only had"—when in reality I have more wealth of life and opportunity at hand than comes to most people in a normal span of life.

I feel a great deal of pride when I realize that I have proven trustworthy enough to be employed in the great task our country has under taken. I know that everything I do, however trivial it may seem on the surface, is one of the basic millions of steps which tend to make a picture complete. For instance, I know every job has a meaning and to this end—what I am doing not only helps us to help our friends over there, but enables us to protect ourselves.

It is like a gigantic puzzle in effect—due to the fact that the digit which I have just posted is simply a numeral. But looking beyond the page upon which it is written, I vision those I love, peace, health, happiness, the American way of living with its appetite for freedom; to exercise one's mind and life; to live as God intended it to be lived; to enjoy the beauty of nature to feel the warmth of the sun upon one; to gaze enraptured upon the glories of the heavens on a clear starlit night; to see the flowers, bedecked smilingly in their brilliant hues as Mother Nature dressed them for the spring; science, art, literature, medicine—and on and on to the things which touch upon the life of everyone.

These things I envision. Then follows a thought of charred ruins, of terror running rampant, of tragedy, starvation, disease, slavery to a hated cause, of a living hell on earth. When these visions have passed, and my eyes alight upon the work at hand, I see it as opportunity—as the tool which has been given to me to help me protest in my modest way, these others throughout the land that are going about tasks other than defense work—and those dear to me.

And so, I shan't mind what my country asks of me through those who employ me, because I know we all have a common task, a common duty and a common destiny in the land we love. And come what may, deep down in my heart I shall know that I have endeavored to do, to the best of my ability, whatever I could for my fellowmen, my country, and myself.

(EDITOR'S NOTE: *The above quoted thoughts of a Douglas woman employe were unsolicited and are reproduced as they were received, uncut and unedited. Airview publishes them in the belief that they represent a cross section of the thoughts and beliefs of America's loyal army of defense workers in the present national emergency).*

THOUGHTS OF A WOMAN DEFENSE WORKER. The Douglas Aircraft monthly magazine *Airview* periodically featured comments from workers about their experiences in the plant. The thoughts, which were usually positive about working as a defense worker, helped to continue recruit the thousands of workers needed to keep production at a high level. (Copyright The Boeing Company.)

The
WAR LABOR
BOARD ORDER

and

What It Means To You

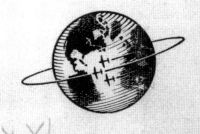

Douglas Aircraft Company, Inc.

WAR BOARD WAGES. The Douglas Aircraft employee had the choice of working on one of three shifts. A regular work day was six and a half hours on the third, or midnight shift, and eight hours each on the first, or day, and second, or swing, shifts. Most aircraft employees worked 10 to 12 hour shifts. Wages were set by Douglas Aircraft until 1943 when the Directive Order of the National War Labor Board standardized job titles and provided equal pay for equal work for all aircraft workers, men and women alike. Wages started at 60¢ per hour for trainees and increased to a high of $1.45 per hour for regular workers and $1.60 per hour for specialists plus a 6¢-per-hour shift differential for second and third shifts. (Copyright The Boeing Company.)

WOMEN WORKERS AND MALE SUPERVISORS. Although women worked side by side with men on the assembly line producing aircraft, men were the supervisors and foremen. Some men resented the women workers and were openly hostile toward them. Recognizing this friction, Douglas Aircraft trained male supervisors using films and newsletters on specifically how to deal with female workers. Women workers were also reminded in newsletters and brochures not to "fly off the handle if the lead man seems gruff. Work hard. Learn your job and cooperate." (Right, Copyright The Boeing Company; below, Franklin Delano Roosevelt Digital Archives.)

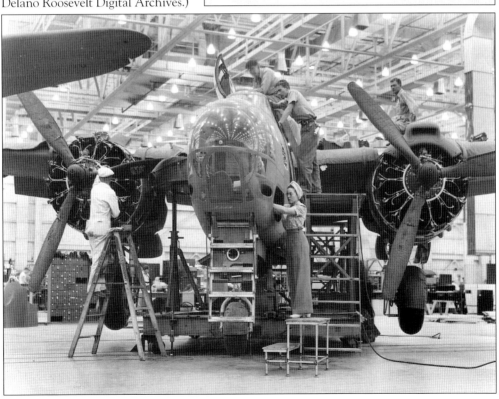

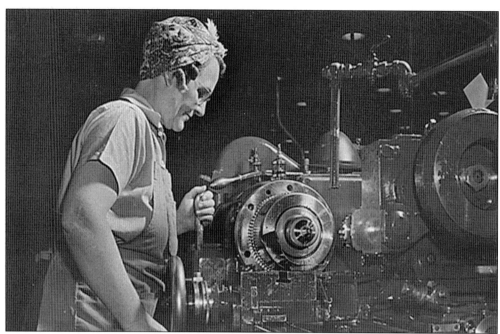

WOMEN OF ALL AGES. Women of all ages worked at the Long Beach plant. The woman operating the lathe in the picture above is in her 60s. Douglas Aircraft Archives include an article regarding 77-year-old Marcia McNey, who worked at the plant on the second shift making flight assembly parts. The two women shown below working inside an unfinished fuselage are mother and daughter. At home, most husbands remained adamantly opposed to their wives working outside the home. But the factories needed workers and propaganda intensified, urging married women with spouses in the military or mothers with sons serving overseas to take aircraft jobs so they could help make the planes needed to win the war and bring the troops home. (Above, Franklin Delano Roosevelt Digital Archives; below, Library of Congress.)

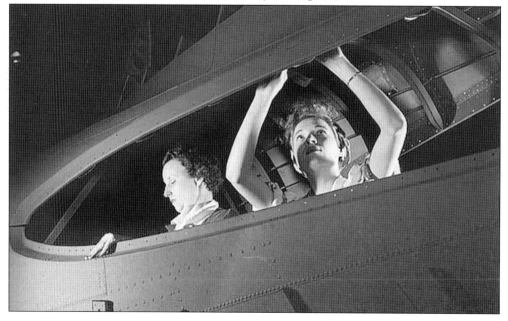

RACIAL DISCRIMINATION A PROBLEM.
For African Americans, the war held the promise of good-paying jobs not available before the war. However, many employers would only employ African Americans in menial jobs or in jobs paying less than their white counterparts. A threatened march on Washington, D.C., by the Brotherhood of Sleeping Car Porters in 1941 spurred President Roosevelt to sign Executive Order 8802, which directed: "There shall be no discrimination in the employment of workers in defense industries or government because of race, creed, color or national origin." The executive order also created the Fair Employment Practices Committee, which investigated complaints and prosecuted employment discrimination. The directive did not address gender discrimination. (Both, Library of Congress.)

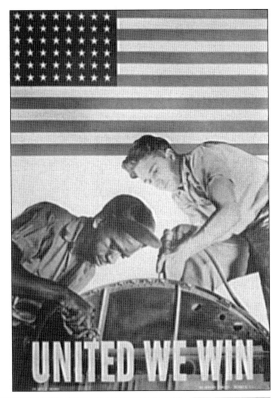

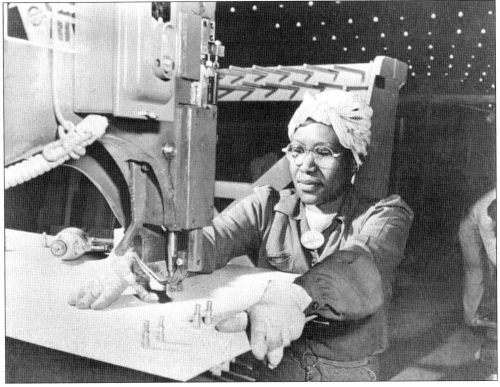

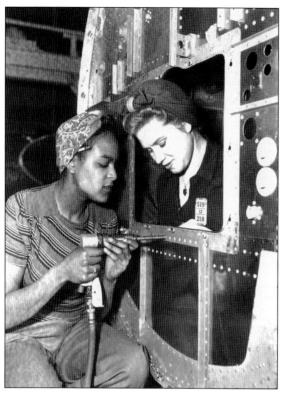

WOMEN OF ALL RACES. Douglas Aircraft claimed to be an "industrial melting pot" due to the fact that men and women of 58 national origins worked side by side producing America's military aircraft in their six factories. The Douglas director of personnel told the press, "Negroes are doing an outstanding job in all plants." Pictured left, Dora Miles (left) and Dorothy Johnson work as a riveting team in an airframe. Dolores Aldrich, pictured below, attaches wires inside the aircraft. These three women worked at the Long Beach plant. Both photographs were taken by Office of War Information photographers and were distributed to the national news media. (Both, Copyright The Boeing Company.)

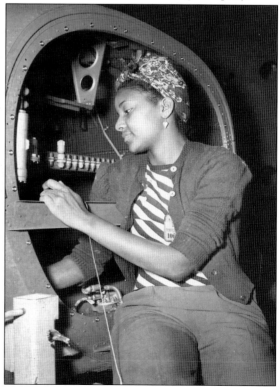

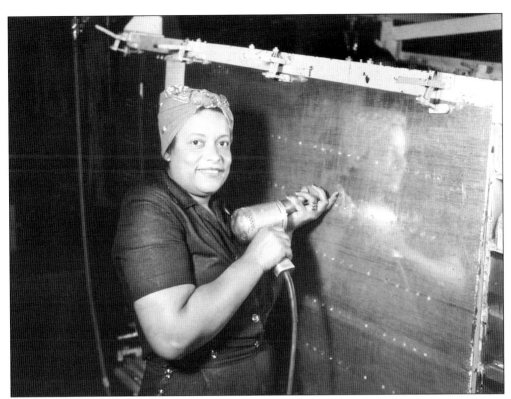

RACIAL TENSION IN LONG BEACH. Even though thousands of workers were needed to meet military production quotas for planes and ships, and many non-white workers were employed by Douglas Aircraft (such as Amanda Smith, pictured on the right on a scaffold), non-white workers had serious problems finding housing and other accommodations in Long Beach. The Long Beach area had restrictive covenants in property titles that prohibited the selling or renting to African Americans. Housing for African American Long Beach workers was confined to an area described by the local press as the "negro section around Anaheim and California avenues." African American women with children had an especially difficult time finding a place to live in Long Beach. (Both, Library of Congress.)

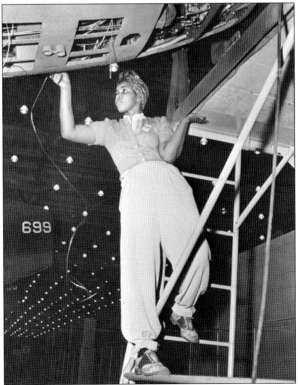

JAPANESE WORKERS NOT WELCOME. The internment of Japanese fishermen and their families, who had docked their boats at Terminal Island adjacent to Long Beach, intensified the anti-Japanese sentiment at the Douglas Aircraft Plant, as reflected in its publications. (Both, Copyright The Boeing Company.)

Four

ROSIE BUILDS AIRPLANES IN LONG BEACH

"ROSIE" BUILDS AIRPLANES. In 1939, there were only 48,638 aircraft workers nationwide. By 1943, that number exploded to 2,102,000. The plants operated by Douglas Aircraft produced 16 percent of all the airplanes used in World War II. They were able to do so because of the high production rate of their thousands of men and women who worked six and seven days a week, sometimes 10 to 12 hours per day. At its peak, more than 46 percent of Douglas's workers were women. Pictured here, Kathyrn Polinare (left) and Vivian King work together to assemble a plane at the Long Beach plant. (Library of Congress.)

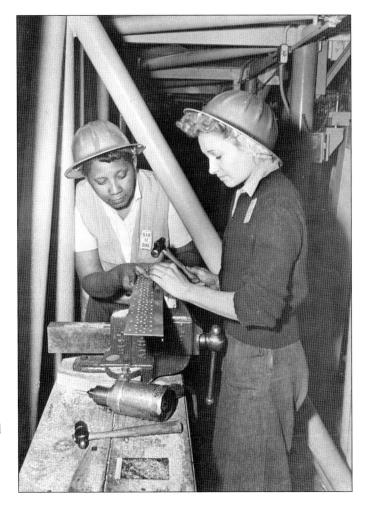

DOUGLAS AIRVIEW

Volume IX OCTOBER, 1942 Number 10

WORKING SIDE BY SIDE. Women worked side by side with the men in the plant. Most men were drafted or enlisted in military service, leaving older men to work on the home front. Males with special expertise needed in the aircraft factory were given an exemption from military service and were allowed to keep their civilian job during the war. Some men tried to quit their jobs and join the military, but they could be arrested by the FBI and returned to their jobs if the plant needed their skills. (Copyright The Boeing Company.)

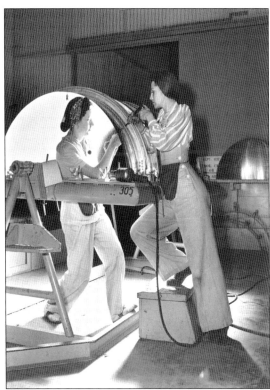

USING THE "BUCK ROGERS" GUN. The rivet gun was referred to as the "Buck Rogers" gun because of its similarity in looks to the gun used by the popular 1928 science fiction character. The rivet gun weighed three and a half pounds and would vibrate forcefully and loudly as it pushed the rivet into the hole. In most cases, one woman would insert the rivet and another woman would be on the inside of the airframe or fuselage using a bucking bar to flatten the end of the rivet while tightening it. The riveter pictured below is working high above the ground on a scaffold so that she can rivet the stabilizer section of the plane. A worker is inside flattening the rivet. Planes were held together with as many as 150,000 rivets. (Both, Copyright The Boeing Company.)

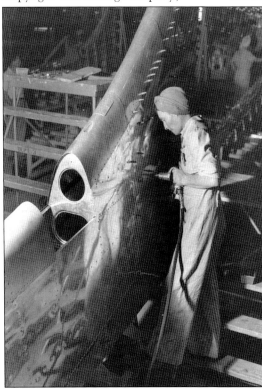

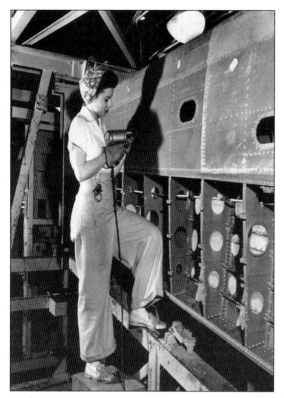

REAL RIVETERS AND MODELS. Being a riveter on the aircraft factory floor meant getting dirty, sweaty, and messy, as shown in the photograph on the left. The Office of War Information brought models to the Long Beach Douglas Aircraft Plant and posed them for hundreds of photographs that would be distributed to the news media or used on posters to recruit women workers. Even though the picture below shows Grace Delong, an actual worker, she is depicted as a well-dressed, clean riveter who apparently forgot to wear her gloves while using the rivet gun on an already-finished section of the airframe. (Both, Copyright The Boeing Company.)

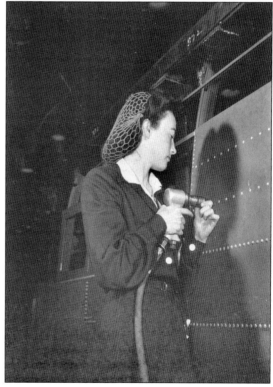

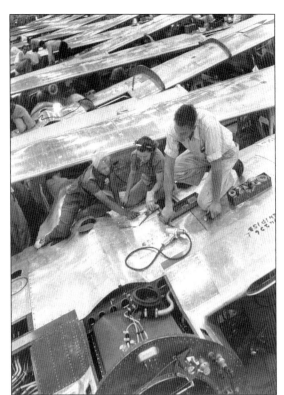

WORKING IN PAIRS. Women worked in pairs, in teams, and singly in the plant. Many women formed friendships with each other as the employment of women in the aircraft industries increased by over 125 percent. The divorce rate also soared as women became financially independent due to their war work. (Both, Copyright The Boeing Company.)

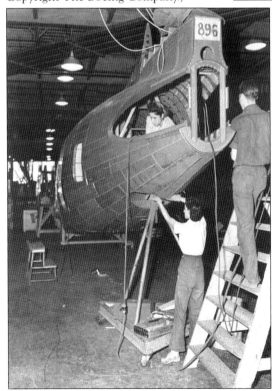

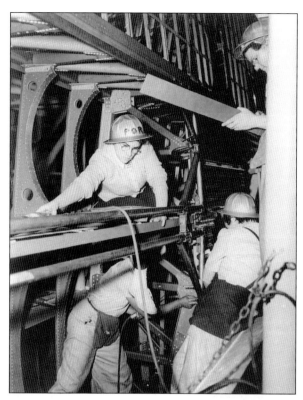

ALL-WOMEN TEAMS. Women sometimes worked in teams comprised of only women, but more often they would work alongside men performing the same jobs. Women were given rest breaks, which brought complaints from some men. Other men complained that they would not ask their wives or sisters to do the type of work done by women at the plant. Douglas Aircraft petitioned the government to allow rest periods for both sexes. (Both, Copyright The Boeing Company.)

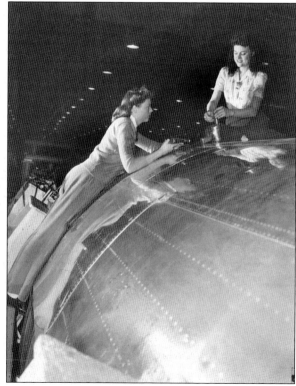

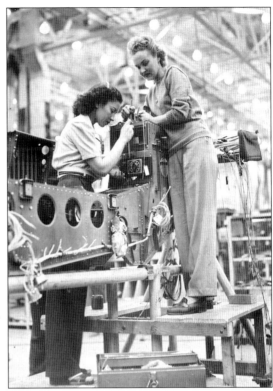

ASSEMBLING PARTS. Planes were so large that they had to be completed in sections and then assembled together. Teams of workers built one section of the plane at a time, known as "pre-completes." This technique, adapted from the automobile industry, eliminated a great deal of time in the production process. The women on the right are working on an electrical assembly. The woman pictured below is inside the nose of a bomber and is also working on electrical wires. The white block on the photograph was placed there by Douglas photographers to hide the military configurations so that the specific plane could not be identified during the war. (Both, Copyright The Boeing Company.)

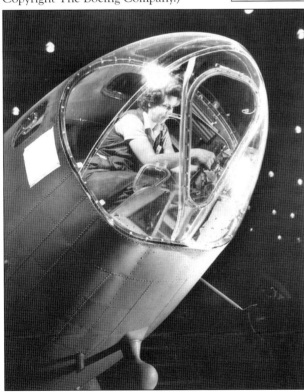

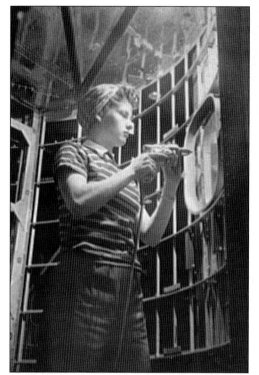

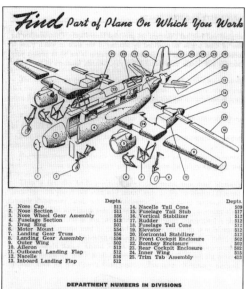

Find *Part of Plane On Which You Work*

		Depts.			Depts.
1.	Nose Cap	511	14. Nacelle Tail Cone		509
2.	Nose Section	511	15. Fuselage Tail Stub		517
3.	Nose Wheel Gear Assembly	556	16. Vertical Stabilizer		512
4.	Fuselage Section	513	17. Rudder		512
5.	Drag Ring	501	18. Fuselage Tail Cone		512
6.	Motor Mount	554	19. Elevator		512
7.	Landing Gear Truss	556	20. Horizontal Stabilizer		512
8.	Landing Gear Assembly	556	21. Front Cockpit Enclosure		502
9.	Outer Wing	502	22. Bombay Enclosure		502
10.	Aileron	512	23. Rear Cockpit Enclosure		502
11.	Outboard Landing Flap	512	24. Inner Wing		515
12.	Nacelle	516	25. Trim Tab Assembly		413
13.	Inboard Landing Flap	512			

DEPARTMENT NUMBERS IN DIVISIONS

Engineering Division—25, 250 to 265. **Contract Administration Division**—12, 120 to 124. **Materiel Division**— 150, 151, 152, 32, 320 to 329. **Tooling Division**—341, 342, 60, 600, 601, 602, 603 to 608, 632, 635, 635, 641 to 646, 649, 651, 652, 653, 654, 659, 671, 672. **Outside Manufacturing Division**—33, 330, 331. **Quality Standards Division**—27, 270, 271, 274. **Manufacturing Division**—30, 300 to 307, 311 to 317, 340 to 345, 35, 350, 360, 361 to 370, 371, 372, 373 to 379, 381 to 389, 391 to 395, 400 to 413, 424 to 429, 451 to 455, 500, 501, 502, 511, 512, 515, 516, 517, 532, 534, 535, 536, 543, 544, 551 to 558, 561, 562, 566, 543, 582, 584, 585, 590 to 597, 599. **Inspection Division**—280 to 287. **Plant Engineering Division**—70, 700 to 716. **Motor Transportation Division**—21, 211, 212, 213. **Personnel Division**—14, 140 to 149, 903. **Industrial and Public Relations Division**—13, 131, 132, 133. **Comptroller's Division**—10, 100 to 112, 990. **Legal Division**—17, 170. **Medical Division**—19, 190, 191, 192. **Plant Protection Division**— 20, 200, 201, 202. **Welfare Division**—13, 180, 181, 182. **Miscellaneous**—901, 902, 904, 906, 907, 910, 911, 912, 913, 914, 915.

165,000 PARTS. Douglas Aircraft built a variety of different types of warplanes, including the light attack bomber series A-20 and A-26, which required the assembly of 165,000 parts. In addition to assembling the parts, workers installed eight .50-caliber machine guns in the nose and three machine guns in each wing and in an upper and lower turret. The A-26s were the last aircraft produced in the light attack category. Heavily armored, the A-20s were capable of fast attack, which is why pilots called them the Havoc. The Long Beach plant built 2,502 of these planes at a cost of $185,892 each. (Above left, Library of Congress; Above right and below, Copyright The Boeing Company.)

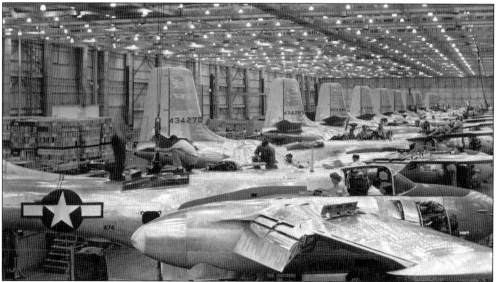

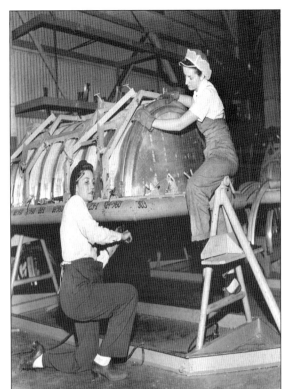

SUBASSEMBLY JIGS. These women are working on subassembly jigs that held parts while they were being put together. The jig held the correct position of the part so that it could be attached. Rivets were used to hold the parts permanently in place. The work was tedious and repetitive, which is why so many workers were needed. (Copyright The Boeing Company and Library of Congress.)

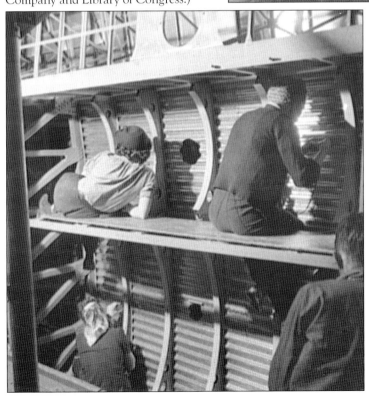

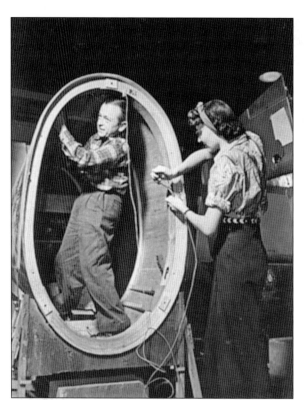

WORKING IN SMALL SPACES.
Building airplanes required some
women to work alone and in small
confined spaces for long periods of
time. The Long Beach plant also
employed small people who could
be lifted into the especially cramped
space of the tail area and inside
the fuel tank. A foreman or co-
worker was responsible for making
sure that the worker inside the fuel
tank was not left there after the
shift was over. Working in confined
spaces or in areas requiring arms
to be raised over the head for long
periods of time resulted in bruises
and muscle strain. (Franklin Delano
Roosevelt Digital Archives.)

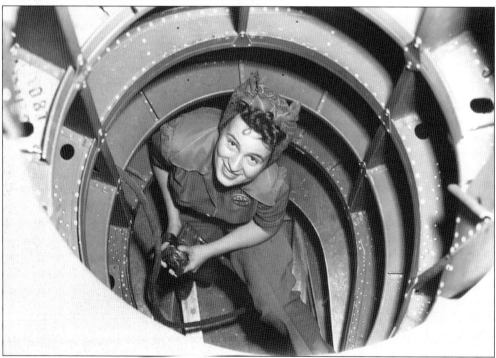

DOWN BELOW. Women working below often complained of having tools, rivets, oil, and metal chips
dropped on their heads by the males working above them. (Copyright The Boeing Company.)

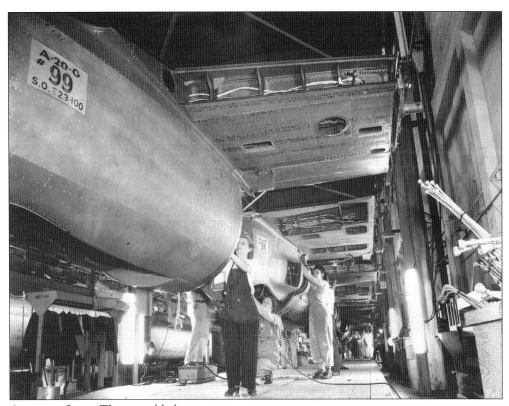

ASSEMBLY LINE. The assembly line was timed so that different parts of the aircraft were worked on by a team of workers and then moved on to the next team on tracks. Work was hectic. Workers were inside and outside of every part of the A-20 attack bomber being assembled in the picture above at the Douglas plant in Santa Monica, California. The same type of assembly-line process was used at the Long Beach plant. (Copyright The Boeing Company.)

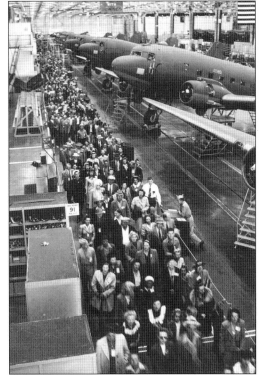

OPEN HOUSE. There was considerable interest from the Long Beach community in the activities of the area's largest employers. This photograph was taken during a 1944 open house at the Long Beach plant, which more than 200,000 people visited. The tracks on which the aircraft were moved can be seen in the photograph. Clocks hung throughout the plant showing the time when the production line was to move to its next point in the assembly process. (Copyright The Boeing Company.)

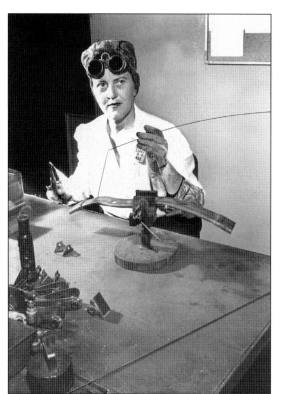

WELDERS AND ELECTRICAL INSTALLERS. Women were trained as welders and electricians because they were considered to have better hand-eye coordination than men. Welders (as pictured on the left) earned more than most occupations at the plant. A welder's hourly pay ranged from 80¢ to $1.25 per hour, depending on the type of welding being done and the experience of the welder. Certain welder occupations were considered specialists and could earn up to $1.60 per hour. Welders wore two badges: their Douglas badge and their welder badge, which contained their name, the identification stamp number they placed on each weld, what type of material they were certified to weld, and whether they were certified in arc or gas welding. Welders had to pass a vigorous army-navy test every six months to keep their jobs. Electrical installers (shown below) were also well paid, with some earning a starting hourly rate of $1. (Both, Copyright The Boeing Company.)

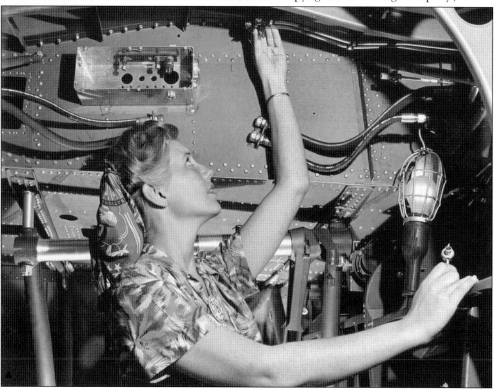

HOW TO USE TEMPLATES

CUTTING METAL. Templates were used to guide the exact location where metal was to be cut to make the many parts needed to build an airplane. Douglas Aircraft outlined how to use templates in Job Instruction Booklet No. 20. The woman pictured below is a model photographed at the Long Beach plant for one of the many photographs used by OWI to recruit female workers to wartime jobs. A real worker would have her goggles in place while cutting the metal. (Both, Copyright The Boeing Company.)

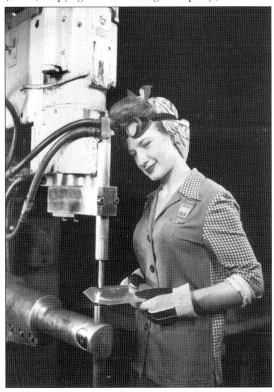

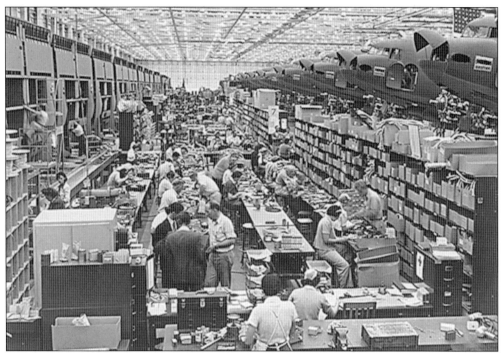

ON THE PLANT FLOOR. The floor of the aircraft plant was crowded with clerical staff, stockrooms, tool cribs where workers checked out tools to do their jobs, and other areas necessary for the production of aircraft. Workers could only access those areas of the plant designated on their badges. The bright lights made it impossible to tell what time of day it was inside the plant. (Above, Franklin Delano Roosevelt Digital Archives; below, Long Beach Airport Archives.)

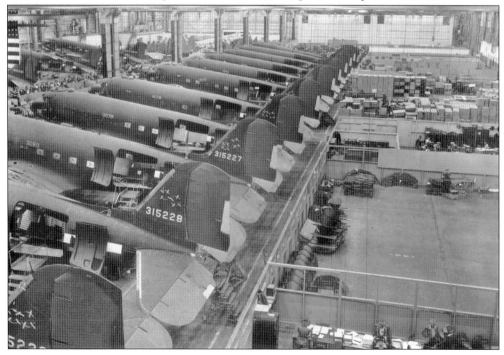

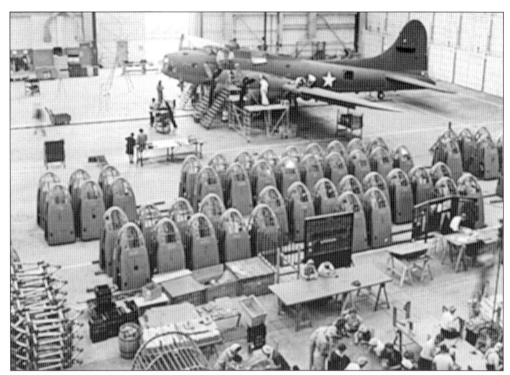

INSPECTIONS AND INSPECTORS.
The last step in the production
of aircraft was an inspection
before the electric doors were
opened and the plane was rolled
out of the building and onto
the tarmac, where it was fueled.
Women pilots from the WASP
then flew these planes to a military
installation. Douglas Aircraft
trained women inspectors like
Audry Tardy, who was featured
on the cover page of the *Airview*
in 1942. The inspectors not only
checked completed aircraft, they
also examined the thousands
of subparts needed to build a
plane. (Above, Franklin Delano
Roosevelt Digital Archives; right,
Copyright The Boeing Company.)

DOUGLAS AIRVIEW

Volume IX FEBRUARY, 1942 Number 2

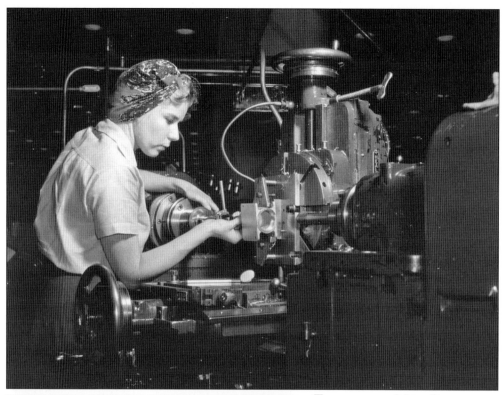

Training for More Difficult Jobs. Douglas Aircraft and Long Beach City Schools trained workers for a variety of jobs that required advanced skills. The women featured in these photographs were actual employees of the Long Beach plant and performed two of the more difficult jobs in the plant. The woman pictured above is cutting a part to a precision measurement on a lathe. The woman on the left is a machinist and an engine mechanic who is working on the powerful, 18-cylinder Pratt-Whitney engine. Two of those engines were mounted on each light attack bomber. (Both, Library of Congress.)

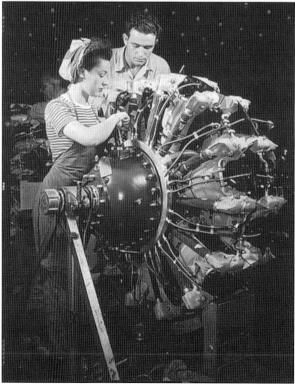

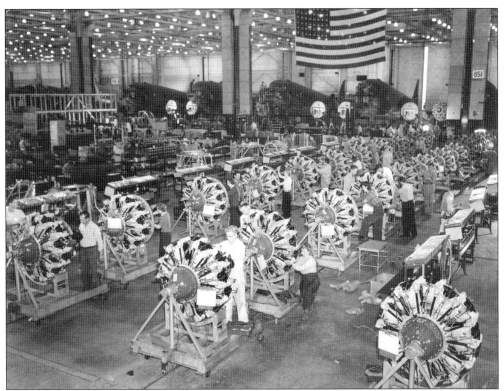

POWER PLANTS. The mighty aircraft engines were referred to as "power plants" because of their size and capacity. The B-17 utilized the powerful Wright Cyclone engine. Capable of 1,200 horsepower, it carried the Flying Fortress to 25,000 feet at speeds reaching 323 miles per hour and made it preferable to other planes that could only fly at lower levels. (Both, Copyright The Boeing Company.)

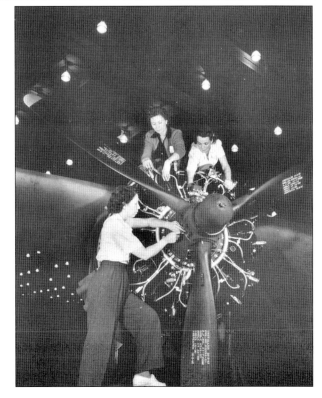

PATRIOTIC WORKERS. Douglas Aircraft often sponsored patriotic employee gatherings such as the one shown in the 1942 photograph to give updates on the war and to encourage faster production of its airplanes. By 1944, workers at the Long Beach plant were producing 16 B-17 bombers per day. (Both, Copyright The Boeing Company.)

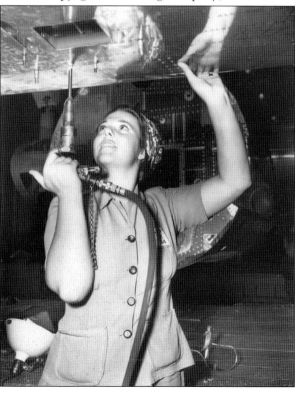

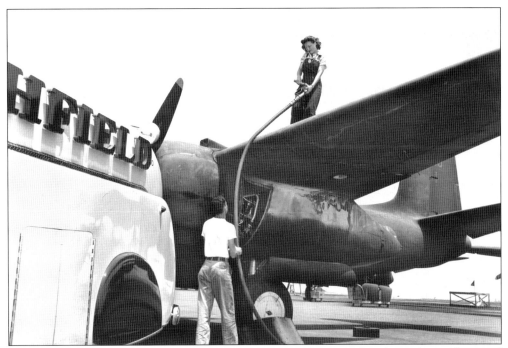

ON THE LINE. Once the planes were finished, they were rolled out of the huge electric doors and onto the tarmac. Women worked the line outside, fueling the planes and adjusting the engines. As late as August 1945, Douglas Aircraft advertisements assured women that the work experience they obtained at Douglas "will stand you in good stead after Victory." (Both, Copyright The Boeing Company.)

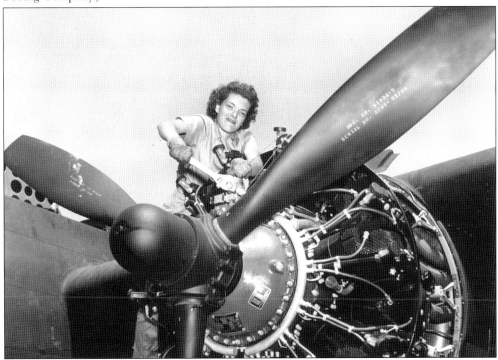

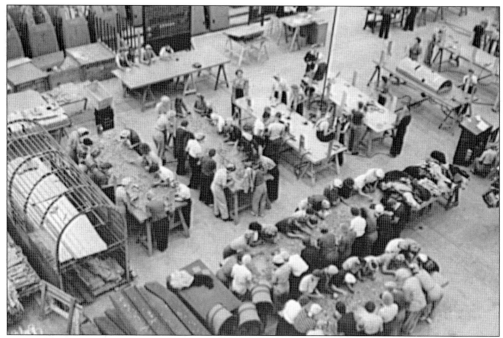

SORTING RIVETS. Women workers performed the tedious but necessary job of sorting millions of rivets. The sorting helped production stay on schedule by keeping the different sizes of rivets in separate boxes. This allowed riveters to quickly put rivets in place without having to stop to find the correct rivet for the particular part they were assembling. (Library of Congress.)

RIVET PANEL. The OWI distributed photographs of rivets panels to show the quality of the work of defense workers. This was to counter comments by military personnel that were questioning whether the planes and ships they manned would hold together in battle because they were riveted by women. (Library of Congress.)

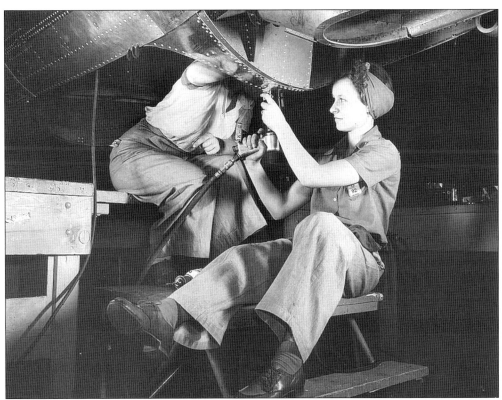

JOBS OF ALL TYPES. Women were hired for a variety of jobs, but because riveting was easy to learn and thousands of workers were needed to rivet, most pictures of women working at the Long Beach plant focused on riveting jobs. The women shown above are doing flush riveting, which makes the rivet flush with the outside aluminum so that the hundred of thousands of rivets do not cause air drag when the plane flies. (Library of Congress.)

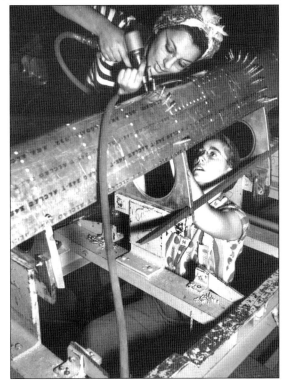

KEEPING TRACK OF RIVETS. Riveters carried a supply of rivets up to their working area and hoped they didn't drop them, which would require a trip down to the floor area. Workers often stepped on rivets and pieces of metal. Those not wearing the heavy-soled safety shoes suffered from punctures and serious injuries to their feet. (Copyright The Boeing Company.)

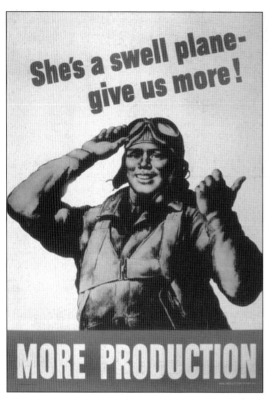

EVERY MINUTE COUNTS. By late 1943, the demand for additional planes increased dramatically. The Aircraft War Production Council, of which Douglas Aircraft was a member, grew alarmed over the loss of 19,000 trained and experienced aircraft workers each month. Some workers grew tired of their jobs and went elsewhere. Housing shortages and inadequate transportation made it difficult for some aircraft workers. Women, particularly, also had the burdens of childcare, shopping, and preparation of food. Banks and stores were closed when women got off work. Food lines often took hours. Many women could not meet these burdens and keep a full-time job. Posters and banners urged increased production, reminding workers that "every minute can count" and that the production of fewer planes would mean a longer war. (Both, NARA)

Douglas Wins "E" Award. The U.S. Army and Navy gave an "E" Award to defense industries that exceeded production quotas. When the "E" Award was given, the plant could fly a special pennant. Each employee would receive a pin at the time the award was given. The presentation ceremony brought out all the plant employees and the recently completed planes. The Long Beach plant received several "E" Awards during the war. (Both, Copyright The Boeing Company.)

LONG BEACH • A Star Is Worn

★ APRIL 4, employes of the Long Beach plant were told by G. A. Huggins, plant manager, that they had again been awarded the Army-Navy "E" pennant, which means that a star will be added to the original pennant bestowed last September 4 on the workers there.

At the request of the Army, there'll be no ceremony, save that employes who joined the Long Beach plant after the first award will now receive their sterling silver "E" pins. Workers hired after April 1, 1944, will henceforth not be eligible for pins until another star is added to the flag six months from that date. April 1 is the date of the letter addressed to the Employe-Management Committee, and is the actual date of the award.

The six months preceeding the award were outstanding in production. In that time, the Long Beach men and women launched the 1000th B-17 *Flying Fortress* and the 3000th C-47 *Skytrain*. All this was done at the same time that the "Wings For Invasion" campaign—General Arnold's request for additional C-47s above present schedules—was successfully pushed.

PAGE THIRTY-SIX

DOUGLAS AIRVIEW

ROOSEVELT COMES TO LONG BEACH. Early on the morning of September 25, 1942, Pres. Franklin Delano Roosevelt's train pulled into the spur track that had been built to connect the Long Beach plant with the Union Pacific Railroad. The plant was surrounded by soldiers. Roosevelt and his entourage, which included Donald Douglas, California governor Culbert L. Olson, and F. W. "Ted" Conant, vice president of manufacturing at the plant, toured the plant by automobile. (Copyright The Boeing Company.)

VISIT WAS TOP SECRET. The visit was a secret to even the top officials of Douglas Aircraft. President Roosevelt spent an hour touring the plant and assembly lines. The visit was Roosevelt's only stop in the Los Angeles area and was part of a two-week, coast-to-coast tour that included stops on the West Coast at Bremerton, Washington, and San Francisco, Camp Pendleton, and San Diego, California. The photograph inside the plant shows two white squares on the planes, which were identification numbers blocked out for national security reasons before the photographs were sent to the press. (Copyright The Boeing Company.)

ROOSEVELT THANKS PLANT WORKERS.
Press accounts of President Roosevelt's
visit declared that of all the plants visited
by the president on his tour, "other
plants did not show the production
seen at the Douglas plant." (NARA.)

"Having seen the quality of the work
and of the workers on our production
lines – and coupling these first-hand
observations with the reports of actual
performance of our weapons on the
fighting fronts – I can say to you that
we are getting ahead of our enemies
in the battle of production."

Franklin D Roosevelt

A SIDE VISIT IN LONG BEACH. After his visit to the plant, President Roosevelt and Governor Olson
rested at this unidentified Long Beach home. (Franklin Delano Roosevelt Digital Archives.)

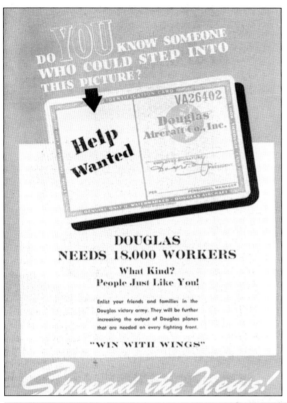

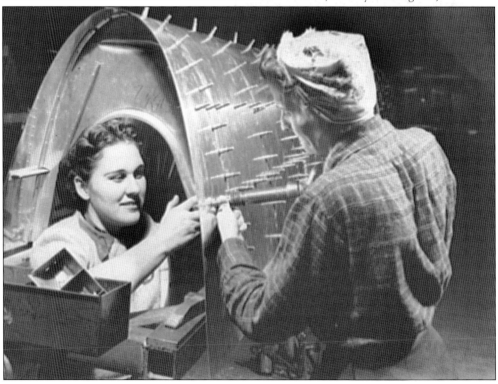

DOUGLAS NEEDS 18,000. To keep up with production quotas, the Long Beach plant needed an additional 18,000 workers in 1942 to complete orders for planes. Absenteeism was a serious problem, partially because workers had little time off between work weeks. Douglas began paying workers on Saturdays so that workers would come to work on the weekend. The Long Beach plant established home-problems advisory services and extensive social and recreational services to deal with the causes of absenteeism. (Left, Copyright The Boeing Company; below, Library of Congress.)

SKATING AT WORK. The Long Beach plant was so large that clerical workers and messengers wore roller skates to deliver interdepartmental documents, blueprints, and mail throughout the plant. Most Americans used clamp-on skates during the 1940s. Shoe skates, as shown in these pictures, were not in common public use until the 1950s. Secretaries, clerks, and female delivery clerks were allowed to wear skirts in the plant. (Both, Copyright The Boeing Company.)

Trains without Tracks

Keeping Every Department Supplied with Material Is a Big Job at Long Beach

● THE ONCE humble Douglas trucker is holding his head high these days—now he is a trainman, not a trucker, and it's a career!

The complexity and equipment of our present internal transportation system would delight the mechanized soul of a railroad man, for they now come complete with dispatchers, block signals, timetables, and all of Casey Jones' gadgets.

Keeping the proper departments supplied with every vital material from paper clips to fuselages presents problems possible to solve only by regulation railroad methods. Over a thousand tons of material per day must be moved on strict schedule in the Long Beach plant alone. Much of the credit for smooth line production belongs to precise performance of this task, and the whipping of transportation problems that would strain the vocabulary of an Army mule-skinner.

Somebody said that civilization depends upon coordinated movement of essential materials. The survival of civilization as we know it also depends upon ultra-fast manufacture of the sinews of war which we of Douglas are helping to produce for ultimate victory.

A Havoc zooming over the dock of Wilhemshaven or a Dauntless screaming out of a dive over the Marshall islands may be a far cry from the humble driver's seat of one of our trackless trains, but they are closer than we might think. Our perspiring trainman may not have so many gadgets to watch, nor is he riding herd on 1200 horsepower—but he too is doing a job that is causing the Japs and the Nazis a big parcel of grief.

At dawn's crack at Long Beach an imposing array of men and equipment are lined up outside the receiving building to recheck the next 24 hour's plans for getting the stuff from here to there. Don't confuse them with the dawn patrol, though; these flyers keep hustling 24 solid hours. They break from the post at 7:55 a.m., each to a known

ON SCHEDULES as strict you could set your watch by them, trackless trains cover Long Beach plant. Trains' "engines," below, also are used to haul airplanes and airplane parts.

DELIVERY RUNS all begin from receiving buildings where dispatcher keeps track of his trackless trains and the goods.

TRAINS WITHOUT TRACKS. The Long Beach plant was so large that it required trains to run throughout the plant to haul airplane parts, office supplies, and food on a set schedule. Delivery runs began at receiving buildings and were dispatched to the many buildings at the plant. Over a thousand tons of material was distributed daily on the trackless railroad. Trains ran 24 hours a day. Materials were brought to the assembly floor so that workers could keep up with production. (Left, Copyright The Boeing Company; below, Franklin Delano Roosevelt Digital Archives.)

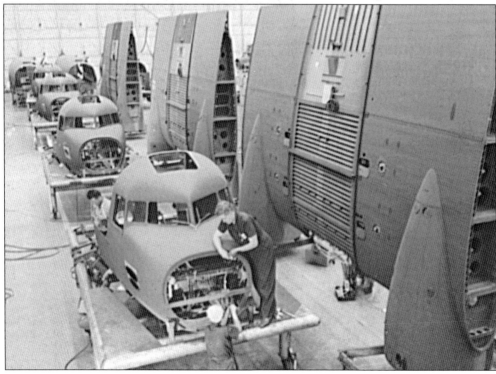

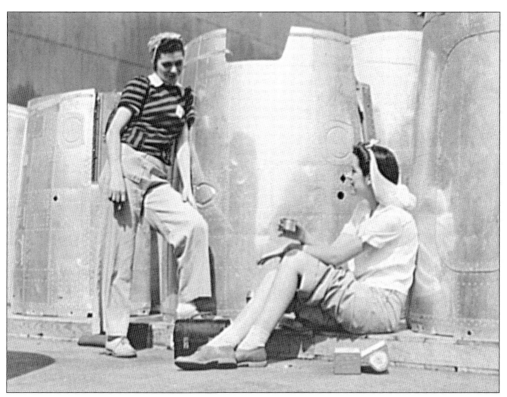

LUNCH BREAKS. The two women shown above are taking a lunch and smoking break outside the plant near nacelles. Nacelles were metal structures that surrounded the engines. Lunch breaks during the night shift were taken inside the plant. Douglas Aircraft included many articles in the employee newsletter on how to pack a nutritious lunch. Douglas also provided low-cost meals at the plant cafeteria. (Above, Library of Congress; right, Copyright The Boeing Company.)

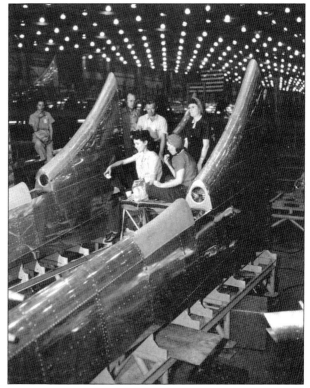

CIGARETTES AND THE WAR. Smoking was popular duringWorld War II as a way to "soothe the nerves." The number of women smoking cigarettes dramatically increased during the war. Douglas Aircraft workers collected funds to provide military troops and patients in veterans' hospitals with cigarettes through its Dime-A-Week benefit fund. (Copyright The Boeing Company.)

A LADY'S AIRPLANE. Douglas Aircraft referred to the B-17 as "A Lady's Airplane" because women crews made most of the mighty bombers produced in the Long Beach plant. The B-17 was the favorite of the U.S. Army Air Corps and the preferred plane of Lt. Gen. Jimmy Doolittle. Many in Congress were not as enamored by the B-17 because of its size and its use of four engines instead of two. To counter Congress's resistance (and its threat not to fund), the U.S. Army Air Corps teamed up with Hollywood and made certain the B-17 was featured in wartime films. As a result, there was much popular support for the plane. (Right, NARA; below, Copyright The Boeing Company.)

FLYING FORTRESS

Deadly Queen of the Skies_ pride of the Army Air Forces

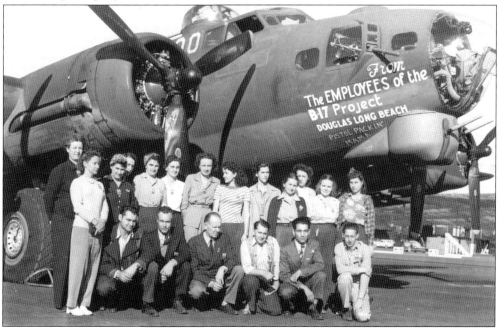

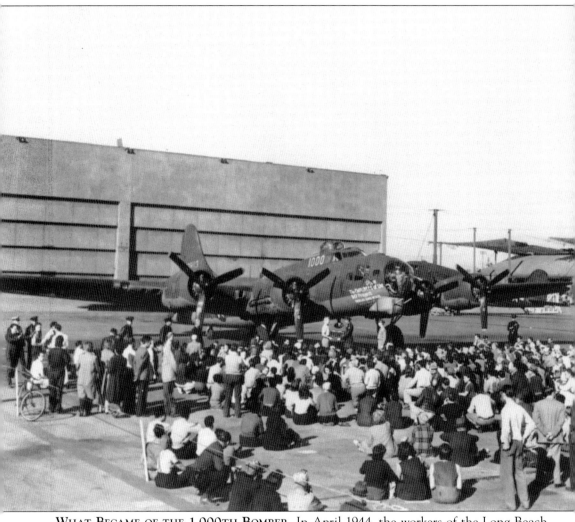

WHAT BECAME OF THE 1,000TH BOMBER. In April 1944, the workers of the Long Beach Douglas Aircraft Plant learned that the 1,000th B-17G Flying Fortress produced at the plant successfully completed many missions over Germany. The workers had purchased the 1,000th B-17 by buying $323,000 in war bonds. Douglas workers raised hundreds of thousands of dollars in war bonds during the war. The B-17G was fitted with more firepower than earlier versions and became the last of the heavy bombers produced at Long Beach. Camouflage netting covering the space between two buildings can be seen in the upper right of the photograph. (Copyright The Boeing Company.)

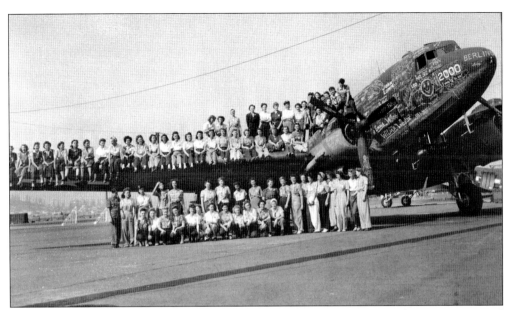

2,000TH C-47. Douglas Aircraft workers pose near the 2,000th C-47 Skytrain cargo- and troop-carrying transport plane produced at the Long Beach plant. By 1944, the War Production Board assigned production of the plane as a top priority over other models at the plant. The increased production once again increased the need for more workers. (Copyright The Boeing Company.)

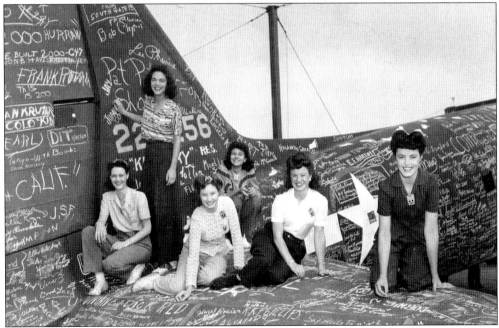

PEN ROMANCES. Workers autographed the planes and wrote messages in chalk on them. Although the messages were rubbed off before the U.S. Army Air Force would accept the plane, some "Rosies" left their names and addresses inside the wheel wells and hidden compartments, and started "pen romances" with U.S. Air Force mechanics who later found the messages while repairing the planes. (Copyright The Boeing Company.)

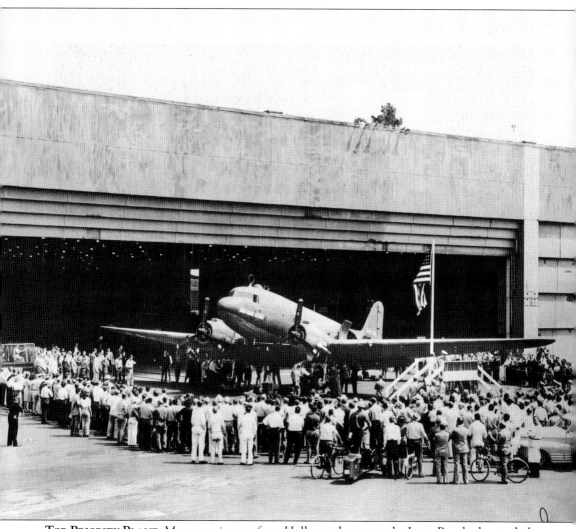

TOP-PRIORITY PLANE. Many movie stars from Hollywood came to the Long Beach plant to help promote the C-47 Skytrain transport plane. The photograph shows actress Ruth Hussey christening a new C-47 on the Douglas flight ramp adjacent to the runway of Long Beach Airport in 1944. Other stars visiting Long Beach included Kate Smith, Lorraine Day, Charlie McCarthy, and Risë Stevens. In February 1944, singer Kate Smith broadcast a show on KNX radio while flying over Long Beach in a C-47. (Copyright The Boeing Company.)

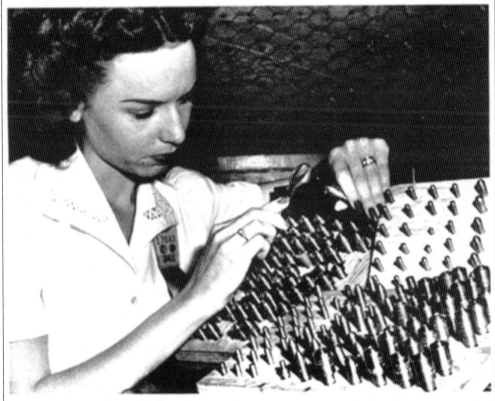

• Worn by work, not by milady, $12,000 worth of diamonds are subjected to regular wear inspection at Douglas Aircraft company, where, brazed into holding tools, they are used extensively to clean and reface grinding wheels and as contact points for testing the hardness of metals. Here Lonell Hudson, tool distribution clerk at Douglas Long Beach plant segregates worn diamonds to be returned to jobber for re-setting.

Industrial diamonds such as these range in size from one-tenth carat to 10 carats and are usually octahedron in shape.

Amsterdam, the industrial diamond center of the world packed up enormous stocks and fled to London after the conquest of Holland. Later, many brokers established themselves in New York, with agents in the largest cities. Greatest source of diamonds for industrial purposes is South Africa. A few trickle in from the Amazon and some from the State of Arkansas, U.S.A., our only domestic source.

Industrial diamonds are usually small, larger ones used being of poor color or otherwise undesirable for the adornment and gratification of those who wear them as jewels.

All measures of hardness start at the top with diamonds. There has never been found anything that will cut them save another diamond. By comparison, other jewels are soft even the sapphire can't mar the diamond in cutting quality. There are cases, therefore, in which nothing but a diamond will do, which makes them highly strategic war material.

INDUSTRIAL DIAMONDS. Douglas Aircraft employed women to inspect the supply of diamonds kept at the plant. Diamond tools were critical for the precision cutting of aircraft parts, control cables, and bracing wires, and for testing the hardness of metals. During World War II, there was a severe shortage of industrial diamonds due to Germany hording them for their own military use and then later invading the diamond-cutting capitals of the world—Antwerp and Amsterdam. Ninety percent of the strategic war diamonds came from South Africa. (Copyright The Boeing Company.)

SCRAP DRIVES. Long Beach Douglas Aircraft employee Annette delSur poses on top of a bin used to collect scrap materials by workers from the plant. Douglas employees were reminded in posters not to waste anything on the job. Materials were in short supply prior to America's entry into the war when planes were being produced for U.S. allies. When the United States entered the war, shortages worsened, and civilians were mobilized to collect all available scrap. Long Beach City Schools collected newspapers, tin cans, and aluminum foil for the war effort. Students could be awarded the status of Paper Trooper for collecting large amounts of paper for recycling. (Above, Library of Congress; left, Copyright The Boeing Company.)

WAR BONDS AND STAMPS. War bonds and stamps were originally known as defense bonds and stamps and were developed by the U.S. government to help the economy by diverting disposable income into savings and to keep citizens from buying scarce goods. After Pearl Harbor, war bonds and stamps were sold to help finance the war, which was eventually to cost the United States over $350 billion. Bonds were sold at rallies, and Douglas Aircraft employees were encouraged to have 10 percent of their wages deducted to buy bonds. Stamps were sold in small denominations and accumulated into a bond. A five-percent surcharge on wages was also taken from workers' pay—a "victory tax" to help fund the war. (NARA.)

LONG BEACH SCHOOLS SELL BONDS. This photograph shows students at Long Beach high schools at Jordan, Poly, and Wilson in formation at one of their many "Victory Fridays" held to raise money to buy bombers. During the "Bonds for Bombers" rallies in 1942 and 1943, the Long Beach City Schools set a goal of raising $900,000 to buy a bomber. On one of the "Victory Fridays" held at Jordan High School, students sold $17,000 in bonds and stamps. The Long Beach Elks launched their own campaign in May 1943 to sell more than $1.25 million in bonds to fund a "Long Beach Bomber." Army generals Jimmy Doolittle and George Patton visited Long Beach during one of its many war bond drives. (NARA.)

BRING 'EM BACK ALIVE! Before the war—this phrase applied to men of courage and adventure who braved the wilds of fetid, murky jungles. Today your son, relative, or the kid in the next block is out there—not for the sport of it—but to stalk a beast more cunning than any lion or tiger—the ENEMY!

YOU can help. Furthermore, it is your *duty* to lend every effort possible to winning the war. Douglas Aircraft offers you the opportunity to share in the thrill of producing combat, cargo and transport planes to supply and fight for your loved ones on every front. A job with Douglas will enable *you* to help BRING 'EM BACK ALIVE!

BRING 'EM BACK ALIVE. The propaganda used to bring women into the defense workforce stressed that the production of planes would not only help win the war, but would also help bring home their husbands, brothers, and sons. As the war drew to a close, women were told that they needed to give up their jobs and to go back home. Many left willingly, while others had little choice. (Copyright The Boeing Company.)

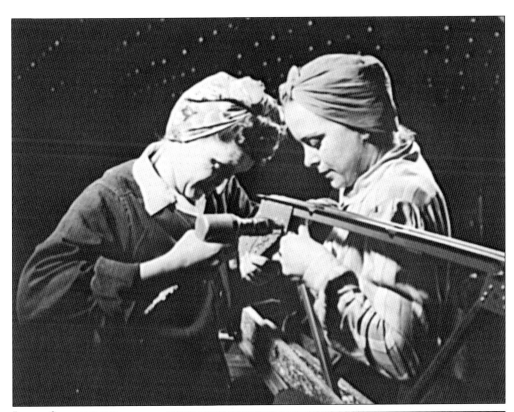

JAPAN SURRENDERS. The surrender of Japan brought the immediate cancellation of orders for military equipment, including airplanes. The Long Beach plant received notice from the U.S. Army Air Force a month prior to the surrender that production of the B-17 bomber was to be halted immediately. Despite the B-17 cut-off, Douglas Aircraft continued producing other types of planes, such as the A-26 attack bomber and the C-54 and C-74 combat air transports. Douglas ran advertisements announcing "critical needs for additional workers" through late September 1945. (Both, Library of Congress.)

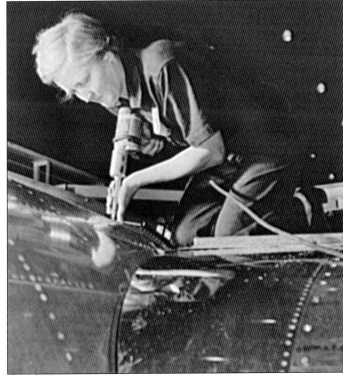

WOMEN LEAVING DOUGLAS. When the war ended, Douglas held $129 million worth of contracts to build airplanes for the military. The contracts were cancelled and so was a great deal of the work. By 1946, the Reconstruction Finance Corporation, which owned the Douglas Aircraft Plant, turned it over to the War Asset Corporation to sell. Donald Douglas purchased a small section of the plant for C-47 production. North American Aviation leased most of the plant, and Henry Kaiser leased the remainder. Douglas eventually purchased the plant for $3.6 million, which was slightly more than a third of the original cost of construction. (Copyright The Boeing Company.)

Five

A Woman's Work Is Never Done

A Woman's Work Is Never Done. The U.S. government told women to "find time for war work" and urged them to take up a number of other duties, including planting victory gardens and sharing their produce to supplement the limited amount of food available through rationing. The Depression's poor economic conditions led to inadequate diets for many men and women, which was of great concern to the military and the defense industry that needed strong, able bodies. Douglas Aircraft included nutrition tips in all of its employee publications, reminding female workers that "a balanced diet will help you balance eight full hours of work in an airplane plant with your household duties." (NARA.)

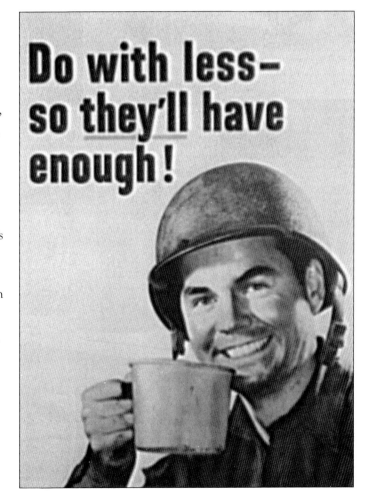

Do with less—so they'll have enough!

BUSY ON THE HOME FRONT. Women were busy on the home front trying to keep their households running while their spouses were off to war. They had to make due with less. Everything was scarce during the war. On a regular basis, citizens were issued war ration books, which contained stamps used to purchase specific goods, gasoline, and foods at prices set by the Office of Price Administration. Each food item was assigned a rationing point, as shown in the photograph above. Women were admonished to carefully use their ration stamps and to only pay officially approved prices for the food. (Above, Library of Congress; below, NARA.)

SUGAR DADDY NEWCOMB. Long Beach residents could register for sugar rationing coupons and pick them up at the Long Beach high schools. The coupons were considered a way to assure a just distribution of the nation's limited sugar supply. The program was coordinated by Douglass Newcomb, who earned the nickname "Sugar Daddy." Newcomb served as the president of the City Teachers Club of Long Beach and then later became superintendent of the Long Beach City Schools. Throughout the war, the Long Beach City Schools and teachers maintained a close relationship with the Douglas Aircraft Plant. (Library of Congress.)

GROW YOUR OWN. Food was in scarce supply during the war. Vegetables were shipped to military troops or were made unaffordable due to high wartime prices. Defense industry workers were encouraged to grow their own food by planting victory gardens, and prizes were offered for the best victory garden grown by a Douglas Aircraft man or woman. Long Beach teachers conducted classes for local residents on how to plant and maintain these gardens. (Copyright The Boeing Company.)

WAR WORKER NURSERIES. By 1943, most of the women working in defense plants were married with children. Employers realized that women workers could not concentrate on their job unless childcare was provided. While most women relied on other family members to care for their children, women with children who relocated to California to take defense jobs found it impossible to work without childcare. Several defense plants, such as the Kaiser shipyards in Richmond, California, built childcare facilities with government assistance. (Library of Congress.)

LONG BEACH AREA NURSERIES. Although Douglas Aircraft did not operate childcare facilities for its workers, Douglas Aircraft newsletters frequently included updated listings of Long Beach–area childcare facilities and childcare workers available to employees. Many of the day nurseries used by the women at Douglas Aircraft were maintained by the Long Beach Board of Education. Others were private or church facilities or home childcare. The cost of childcare varied depending on the facility but averaged 60¢ a day, including meals. Douglas recruitment brochures assured women that these places provided "the best of childcare and supervision." (Library of Congress.)

HOUSING PROBLEMS. Douglas Aircraft operated a housing bureau to aid workers in finding a house, apartment, or room and board. Housing was in short supply for the thousands of women and men who came to the West Coast for jobs in the defense industry. Long Beach city prosecutor Albert Ramsey became involved when workers from midwest and eastern states were recruited for jobs in Long Beach with promises of houses for rent for $35 per month even though none were available. Whole families had to sleep in their automobiles or in tents in city parks until they could find housing. (Copyright The Boeing Company.)

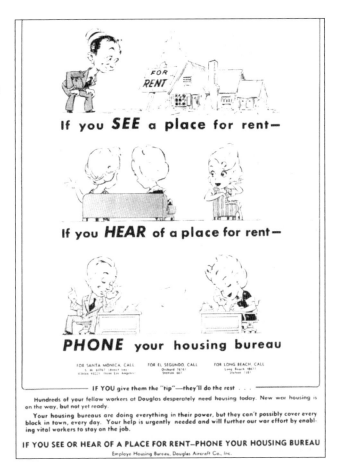

NORTH LONG BEACH HOMES. Douglas Aircraft, in conjunction with the Federal Public Housing Agency, constructed 700 small, one- and two-bedroom homes in North Long Beach for its workers to rent that were fully furnished at a cost of $37.90 to $60 per month. Homes adjacent to the plant (in the area later known as Lakewood Village) were rented for $50 a month. Small one-bedroom units were built for around $1,100 and placed in backyards so that homeowners could make extra money by renting them to aircraft workers. (Copyright The Boeing Company.)

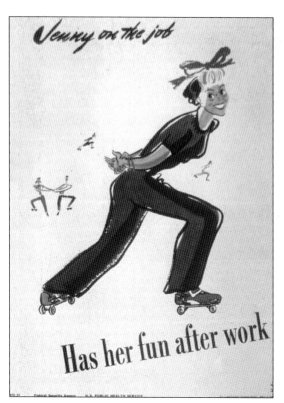

Jenny on the job

Has her fun after work

FUN AFTER WORK. U.S. government posters encouraged female workers to take time after work to have fun. Employers like Douglas Aircraft had extensive recreational programs and also offered a variety of musical programs and rallies during the lunchtime break. (NARA.)

"BOMBARDIERS." Despite the long hours at work, women employees participated in a number of after-work activities, such as the "Bombardiers" bowling team. Douglas Employee Recreation offered other sports, singing groups, drama clubs, dances, and traveling minstrel shows complete with full blackface. (Copyright The Boeing Company.)

NO SILK STOCKINGS. Women gave up much during the war, including their silk and nylon stockings. Used silk stockings were perfect gunpowder bags that held a charge of gunpowder needed to fire big guns. After firing, the silk dissolved, leaving a clean gun barrel. Nylon stockings, first introduced in the late 1930s, were also used in parachutes, tents, ropes, and tires. Women dealt with the lack by wearing rolled-down white socks or by applying make-up and an eyebrow pencil line to their legs. (Library of Congress.)

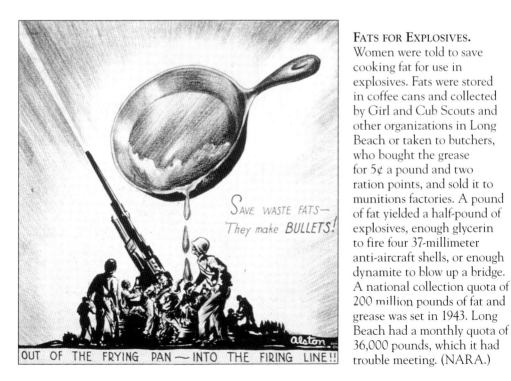

SAVE WASTE FATS— They make BULLETS!

OUT OF THE FRYING PAN — INTO THE FIRING LINE!!

FATS FOR EXPLOSIVES. Women were told to save cooking fat for use in explosives. Fats were stored in coffee cans and collected by Girl and Cub Scouts and other organizations in Long Beach or taken to butchers, who bought the grease for 5¢ a pound and two ration points, and sold it to munitions factories. A pound of fat yielded a half-pound of explosives, enough glycerin to fire four 37-millimeter anti-aircraft shells, or enough dynamite to blow up a bridge. A national collection quota of 200 million pounds of fat and grease was set in 1943. Long Beach had a monthly quota of 36,000 pounds, which it had trouble meeting. (NARA.)

MAKE SURE TO WRITE HIM. In between work, household chores, and childcare, women were urged to write letters every day to the men serving overseas. "V-Mail" or "Victory mail" required writers to use a special form that was then microfilmed and shipped overseas. The messages were blown up to readable size before being given to the soldiers. V-Mail decreased the space needed to ship correspondence overseas and also allowed the military to ensure sensitive information concerning troop locations was not included. Most people, however, still sent regular letters to their men in the military. (Library of Congress.)

IN MY SPARE TIME. This 1940s cartoon illustrates how busy women were during the war and the many demands that were placed upon them. Women were expected to keep the household running, take care of their children, comply with government directives regarding rationing and conserving materials, and keep in touch with their husbands while working full-time in physically demanding jobs. (Library of Congress.)

Six

OTHER LONG BEACH ROSIES

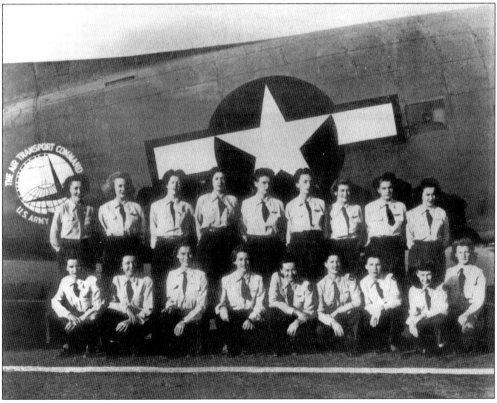

WASP. After the planes were built at the Long Beach Douglas Aircraft Plant, women civilian pilots known as the Women's Auxiliary Ferrying Squadron (WAF) and later known as the Women Air Force Service Pilots (WASP) flew the completed aircraft from Long Beach to airbases and other locations. WASP were stationed at the 6th Ferrying Group at the Long Beach Army Airfield. The women pilots flew thousands of dangerous missions, and by the end of World War II, 38 had died either in training or flight accidents. WASP were deactivated in December 1944. (Long Beach Airport Archives.)

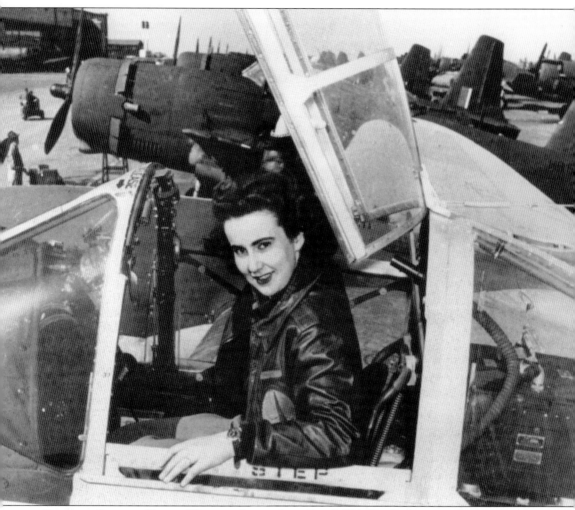

BARBARA LONDON DIXON. The most famous Long Beach WASP is Barbara London Dixon, who was the only WASP honored with the Air Medal during her World War II service. Barbara was originally part of WAFs, and at the age of 22, she was put in charge of the 6th Ferrying Group at Long Beach. Barbara London Drive was dedicated in her honor at the Long Beach Airport in 2005. (Long Beach Airport Archives.)

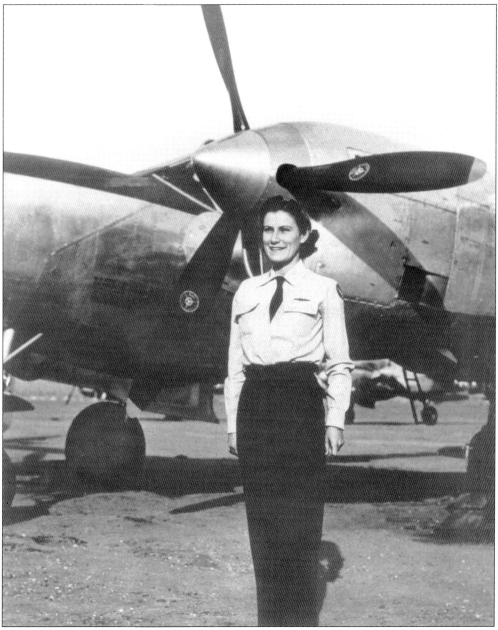

IRIS CRITCHELL. Iris Critchell was a member of the Long Beach WAF and then the WASP. Also a member of the 1936 U.S. Olympic swim team in Berlin, she became the first woman to complete civilian pilot training at the University of Southern California. Critchell served until 1944, having flown 18 different types of planes. She went on to develop the curriculum for the aviation program at Harvey Mudd College. She lives in Claremont, California. (Long Beach Airport Archives.)

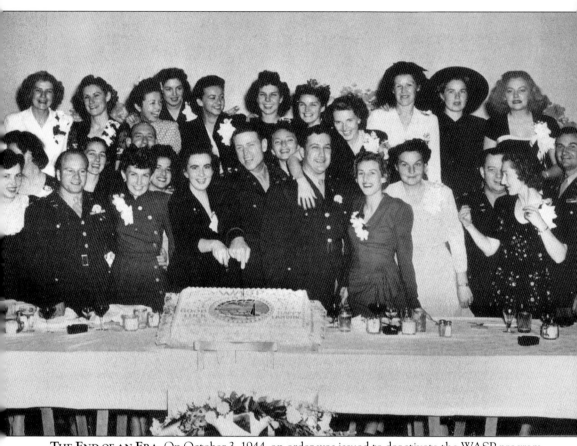

THE END OF AN ERA. On October 3, 1944, an order was issued to deactivate the WASP program due to complaints from male aviators. The program was officially deactivated on December 20, 1944, and the active 916 WASP left the service of their country. Women who had served as WASP were denied medical care for the injuries they suffered and could not receive any of the benefits given to military veterans. It took until 1977 for Congress to pass legislation giving veterans' status to WASP, and in 1979, they were finally given honorable discharges. (Long Beach Airport Archives.)

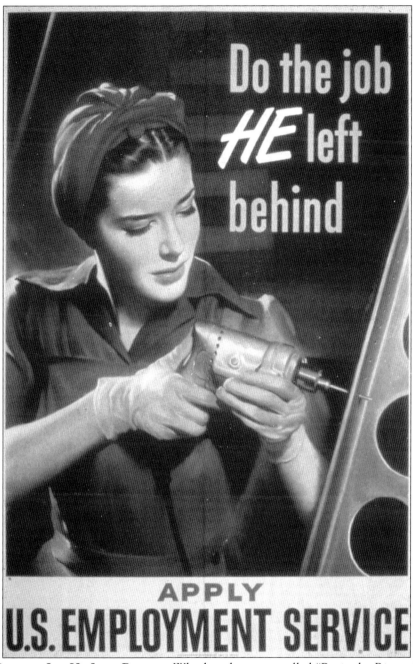

THEY DID THE JOB HE LEFT BEHIND. Whether they were called "Rosie the Riveter," "Tilly the Toiler," "Winnie the WAC," or "Barbara the Burrer," women did the jobs normally held by men before they went off to the war. Not only did women work at the Long Beach aircraft plant, more than 3,000 women worked in the Long Beach Terminal Island Naval Shipyard as welders, chippers, burrers, electricians, boilermakers, pipefitters, and riveters. By the end of the war, women were again bombarded by propaganda—this time their government told them to "go home." By 1954, there were only 2,604 "Rosies" working at the Douglas Aircraft Plant in Long Beach. (NARA.)

BETTE MURPHY, LONG BEACH'S MOST FAMOUS "ROSIE." In 1942, twenty-four-year-old Bette Murphy quit her job as a practical nurse to work at the Long Beach Douglas Aircraft Plant. Murphy, a native of Staten Island, New York, worked as a riveter on the B-17 bomber. She helped organize the first labor union—United Auto Workers Aerospace Local—at Douglas in 1944 and had to secretly collect union dues (which totaled 50¢ a month) from workers who wanted to join but were afraid of losing their jobs. Murphy worked at the plant when it was Douglas and then later McDonnall Douglas. She was the first woman supervisor and the first woman manufacturing engineer at Douglas. In 1979, she became disabled but went on to serve as president of the UAW (now known as United Aerospace Workers) Retirees. (*Long Beach Business Journal.*)

Seven

CELEBRATING
ROSIE THE RIVETER

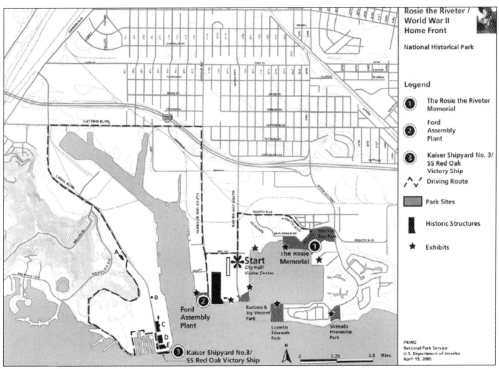

ROSIE THE RIVETER WORLD WAR II HOME FRONT NATIONAL HISTORICAL PARK. During World War II, the city of Richmond, California, was the home to over 56 war industries, more than any other city its size in the United States. Richmond was the site of the Kaiser shipyards, which employed thousands of "Rosies." Women comprised more than 60 percent of the workers at the Kaiser shipyards. The four Kaiser shipyards turned out more ships than any other shipyard in the United States. In 1997, the City of Richmond created the first Rosie Memorial as a national tribute to the women who worked on the home front. In October 2000, Pres. Bill Clinton signed into law legislation sponsored by Congressman George Miller (D-Martinez) establishing the Rosie the Riveter World War II Home Front National Historical Park on the land encompassing the former Kaiser shipyards and other industrial sites used in the war. The park received a national park designation but is owned by the City of Richmond. (National Park Service.)

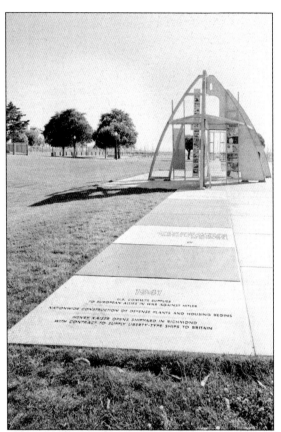

ROSIE THE RIVETER MEMORIAL SCULPTURE. A metal sculpture in the shape of a Liberty ship being built gives visitors to the Richmond park a sense of the size of some of the ships worked on by the thousands of "Rosies" who worked in the shipyards. Photographs and kiosks help to explain the type of work done by the women. The sculpture was designed by Cheryl Barton and Susan Schwartzenberg. (Both, Library of Congress.)

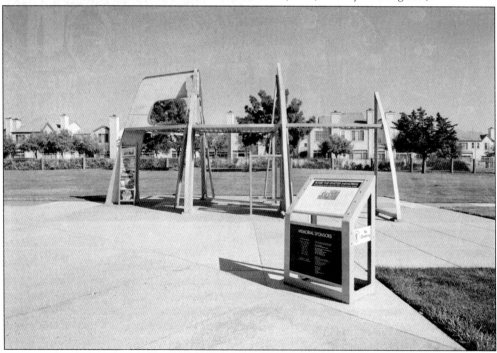

OVER 1.2 MILLION SOUTHERN BLACK WORKERS MIGRATE NORTH
AND WEST FOR INDUSTRIAL DEFENSE JOBS

HEAVY INDUSTRIES ADOPT NEW SKILL CLASSIFICATIONS,
CHANNELING WOMEN AND MINORITIES INTO LOWEST PAID JOBS

AFL-CIO ADOPTS NO-STRIKE PLEDGE DURING WAR

KAISER BEGINS A HEALTH-CARE PROGRAM FOR SHIPYARD WORKERS

HISTORICAL PAVERS. Thirteen pavers are laid out in the outline of a ship and mark the key events that brought so many women into the workforce and the contributions they made to help win World War II. Another 13 cement pavers contain quotes from women who worked on the home front in the shipyards and factories. (Gerrie Schipske.)

PHOTO PANELS. Alongside the metal sculpture are metal panels containing photographs and memorabilia about the women who worked in the Kaiser shipyards. (Library of Congress.)

CONFINED SPACES. This photograph shows the circular metal sculpture in the distance that gives visitors an idea of the confined spaces women welders and riveters worked in while producing the 747 warships in the Kaiser shipyards. In the future, the park plans on reopening the Kaiser Hospital on the site of the first prepaid, medical care program for workers and the Maritime and Ruth Powers Child Development Centers, which provided childcare so that women could work. (Library of Congress.)

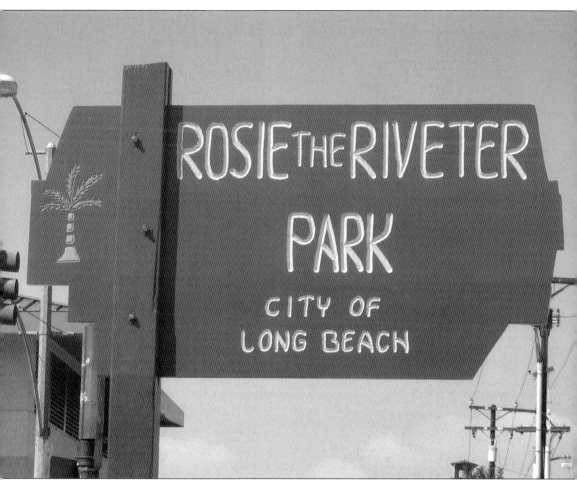

ROSIE THE RIVETER PARK, LONG BEACH, CALIFORNIA. In March 2006, Long Beach councilwoman Gerrie Schipske officiated at the dedication of a one-acre parcel adjacent to the site of the former Douglas Aircraft Plant at the corner of Conant Street and Clark Avenue. Known as the Douglas Park in honor of Donald W. Douglas, the park was renamed the Rosie the Riveter Park in honor of the thousands of women who worked at the Long Beach aircraft plant during World War II. Several of the Long Beach "Rosies" attended the park dedication. (James L. Turner.)

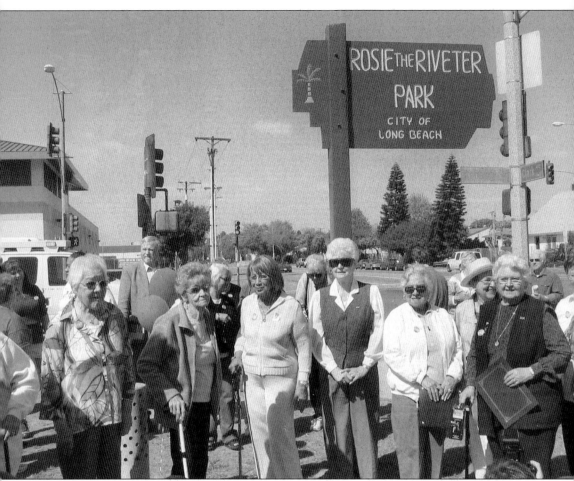

PARK DEDICATION. The March 2006 Long Beach Rosie the Riveter Park dedication ceremony acknowledged the attendance of several women who actually had worked at the Long Beach plant and who had helped assemble the B-17s. Several participants recounted that they took wartime jobs while their husbands were in military service. (James L. Turner.)

THE AUTHOR. Following World War II, Gerrie Schipske's parents met at the Long Beach amusement park, the Pike. Her father, Norman, a native of New Jersey, was an 18-year-old U.S. Marine assigned to the USS *Topeka*, which docked in the Long Beach Naval Station. Her mother, Mary, a 17-year-old transplant from Pennsylvania, came to California with her family so that her father could build houses. Married at St. Lucy's Catholic Church on the west side of the city, her parents settled at Truman Boyd Manor, a housing complex named in honor of a World War II soldier. Gerrie was born in 1950 at the Long Beach Naval Hospital. She is a registered nurse practitioner and attorney at law. She has taught women's studies and political science at California State University at Long Beach. In 1992, she was elected to the Long Beach Community College Board of Trustees. In 2006, she was elected to the Long Beach City Council and represents the 5th Council District. Councilwoman Schipske is working to link the Long Beach Rosie the Riveter Park with the National Park Service World War II Home Front program and to create a lasting memorial and educational program about the women. (Heritage Photography.)

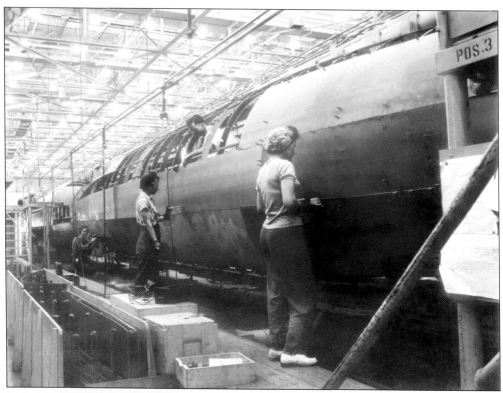

POS.3

WORKING ON THE ASSEMBLY LINE. Long Beach Douglas Aircraft Plant workers performed their taskes while they were timed by assembly line clocks. In the photograph above, women workers are riveting the outside, while men work on the inside. (Long Beach Airport Archives.)

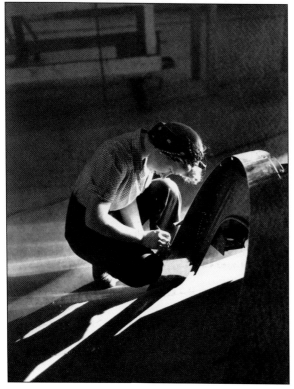

LOLA ASHBY. This 1943 photograph shows Long Beach Douglas Aircraft Plant worker Lola Ashby putting the final touches on a part headed for assembly. (Copyright The Boeing Company.)

RESOURCES

HISTORICAL SITES

The Long Beach Rosie the Riveter Foundation
P.O. Box 50037
Long Beach, CA 90815
www.lbrosie.com

Rosie the Riveter Park Long Beach
Department of Parks, Recreation, and Marine
City of Long Beach
2760 Studebaker Road
Long Beach, CA 90815-1697
Telephone: 562 570-3170
www.longbeach.gov/park/default.asp

Rosie the Riveter World War II Home Front
1401 Marina Way South
Richmond, CA 94804
Telephone: 510 232-5050
www.rosietheriveter.org

WEBSITES

Boeing Archives, www.boeingimages.com/
Franklin Delano Roosevelt Digital Archives, www.fdrlibrary.marist.edu/
NARA, www.archives.gov/
Northwestern University Library Collection: World War II Poster Collection, www.library.
 northwestern.edu/govinfo/collections/wwii-posters/index.html
Long Beach Business Journal, www.lbbj.com
Long Beach Municipal Airport, www.longbeach.gov/airport/
U.S. Library of Congress: Journeys and Crossings, www.loc.gov/rr/program/journey/rosie.html

BOOKS

Albrecht, Donald, ed. *World War II and the American Dream: How Wartime Building Changed a
 Nation.* Washington, D.C.: National Building Museum and M.I.T. Press, 1995.
Bowman, Constance and Clara Marie Allen. *Slacks and Calluses: Our Summer in a Bomber
 Factory.* New York, Toronto: Longmans, Green and Company, 1944. Reprinted 1999 by the
 Smithsonian Institution.
Gluck, Sherna Berger. *Rosie the Riveter Revisited: Women, the War, and Social Change.* Boston:
 Twayne Publishers, 1987.
Stoff, Joshua. *Picture History of World War II American Aircraft Production.* New York: Dover
 Publications, 1993.
Wrynn, V. Dennis. *Forge of Freedom: American Aircraft Production in World War II.* Osceola, WI:
 Motorbooks International Publishers and Wholesalers, 1995.

Across America, People are Discovering Something Wonderful. Their Heritage.

Arcadia Publishing is the leading local history publisher in the United States. With more than 4,000 titles in print and hundreds of new titles released every year, Arcadia has extensive specialized experience chronicling the history of communities and celebrating America's hidden stories, bringing to life the people, places, and events from the past. To discover the history of other communities across the nation, please visit:

www.arcadiapublishing.com

Customized search tools allow you to find regional history books about the town where you grew up, the cities where your friends and family live, the town where your parents met, or even that retirement spot you've been dreaming about.